LETTS PRACTICAL ART

ACRYLICS

A STEP-BY-STEP GUIDE TO
ACRYLICS TECHNIQUES

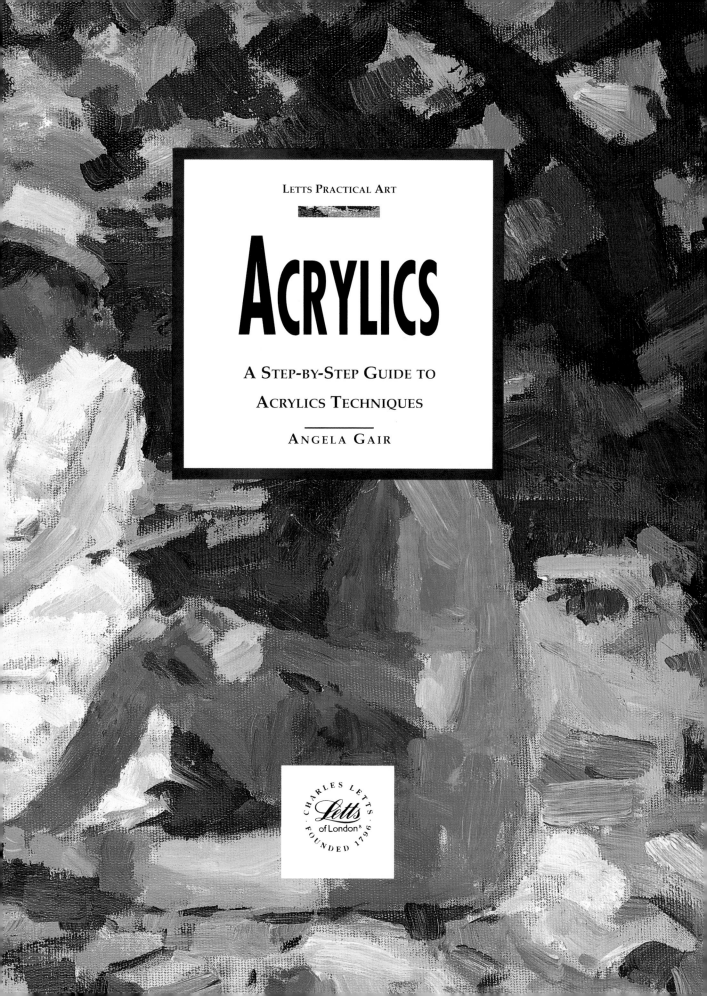

LETTS PRACTICAL ART

ACRYLICS

A STEP-BY-STEP GUIDE TO
ACRYLICS TECHNIQUES

ANGELA GAIR

CHARLES LETTS
Letts
of London®
FOUNDED 1796

First published in 1994
by Letts of London
an imprint of New Holland (Publishers) Ltd
London • Cape Town • Sydney

Designed and edited by
Anness Publishing Limited
Boundary Row Studios
1 Boundary Row
London SE1 8HP

ISBN 1 85238 419 0

New Holland (Publishers) Ltd
37 Connaught Street
London W2 2AZ

A CIP catalogue record for this book is available from the British Library

'Letts' is a registered trademark of Charles Letts & Co Ltd

Editorial Director: Joanna Lorenz
Project Editor: Judith Simons
Designed and Typeset by: Axis Design
Photographer: Ken Grundy

Reproduction by J Film Process (S) Pte Ltd
Printed and bound in Italy by Milanostampa

ACKNOWLEDGEMENTS

Special thanks are due to Winsor & Newton, Whitefriars Avenue,
Harrow, Middlesex, for providing the materials and equipment featured
and used in this book; Sean Kelly Gallery, 21 London Road, London, for
supplying additional materials; The National Acrylic Painters'
Association; and Annie Wood for her invaluable help.

CONTENTS

INTRODUCTION

Acrylic paint is a synthetic, man-made product of modern science. The coloured pigments are essentially the same as those used in traditional media, but the vehicle is a transparent acrylic polymer. Once applied to the support the paint dries in a matter of minutes, and once dry it forms a tough, flexible film that is insoluble in water and will not rot, discolour or crack. This gives acrylics an advantage over oil paints, which do not remain flexible but become quite brittle, and yellow and darken with age.

Acrylics are an extraordinarily versatile medium. They can be used opaquely, like oils or gouache, or thinned with water to create effects identical to those of watercolour. The most outstanding quality of acrylic paint is the speed with which it dries. The rapid drying time is a problem for some artists – the paint cannot be brushed and moved around on the canvas in the same way as oils – but the advantage is that succeeding layers of colour can be built up rapidly without disturbing the underlying layers, and mistakes can be covered easily, even when painting a light colour over a dark one.

Hyena Stomp *Frank Stella*

Here Stella has created a clockwise "spiral" of vibrantly coloured stripes that set up a strange visual sensation; the picture seems at one moment like a square tunnel, the next like an aerial view of a stepped pyramid. The precise geometry of the square was achieved by brushing colour into areas that had been isolated with strips of masking tape, thus creating razor-sharp edges between each stripe, with a fine line of unprimed canvas between.

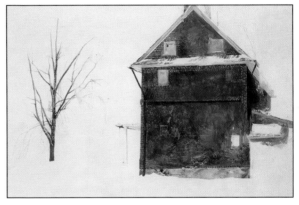

Study for Tenant Farmer *Andrew Wyeth*

Many of Wyeth's paintings depict a lonely rural world, bleak and uncompromising. Here a delapidated farmhouse and a spiky, dead tree stand out starkly against a cold winter landscape, the mood of the scene underlined by the muted palette of browns and greys.

Another advantage of acrylics is that they are insoluble once dry. This means that the traditional technique of building up areas of colour in a series of transparent layers, or glazes, can be achieved in a matter of minutes and without risk of losing the clear brilliance of each colour. Oils are slow-drying, so glazing is a lengthy procedure because each layer must dry before the next is applied.

The development of acrylic paints as a fine art medium came about as an indirect result of technological advances made in the plastics industry in the 1920s. An American firm, Rohm and Haas, invented the first synthetic resins for use

in making a host of products, from household utensils to aircraft windows to false teeth. These early polymers were eventually developed as a base for house paints, providing a durable and weatherproof replacement for distemper.

Meanwhile in Mexico a group of artists, including Diego Rivera (1886–1957) and David Alfaro Siqueiros (1896–1974) were engaged in painting large murals for public buildings. Finding that oil paints were not stable enough to withstand outdoor weather conditions, they experimented with the new acrylic paints and found them quite successful.

These early resin emulsions were not available in saturated colours because they solidified when mixed with a pigment, therefore they were of little use to fine artists. But by the 1950s these problems had been overcome and acrylic artists' paints were available in the United States. By happy coincidence, this was an era of change and experimentation in American art, and the new medium played a pivotal role in

Whaam! *Roy Lichtenstein*

This picture is painted on two separate canvas panels and uses imagery derived from war comics. In some areas of the image Lichtenstein mimics the mechanical printing process of dot shading used in comic-book production; he placed a metal mesh screen on the canvas and brushed paint through the regularly spaced holes with a toothbrush.

the Abstract and Pop Art movements that emerged. Being extremely easy to use, versatile in application, and, most importantly, extremely fast-drying, acrylic paints minimized the artists' involvement with the technical skills of painting, leaving them free to explore the purely creative aspects.

The Abstract Expressionists challenged the notion that a picture was the end result of a planned design. For them the action of applying the paint determined the outcome – hence they became known as "Action painters". The fast-drying quality of acrylic paint was a godsend to such painters, for it allowed them to build up thick layers of paint rapidly and intuitively, knowing that they would dry within a matter of hours or even minutes – something which is impossible with oils.

The most renowned of these painters, Jackson Pollock (1912–1956) placed enormous canvases on the floor and moved rapidly around the picture from all sides, pouring and dripping paint directly from the can, or using sticks to fling it on with whiplash strokes to create a wild tracery of lines and spots of colour.

As a demonstration of acrylic's unique versatility, the medium was adopted just as enthusiastically by Abstract and Hard Edge painters such as Mark Rothko (1903–1970), Frank Stella (born 1935) and Morris Louis (1912–1962). These artists played down personal expression and adopted a more considered approach to the han-

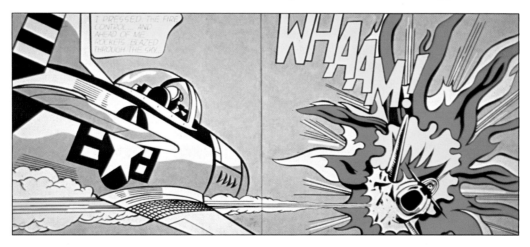

A Bigger Splash *David Hockney*

Acrylic paints have a high degree of opacity and are easily brushed out to give flat, level areas of colour. Hockney found these qualities ideal for conveying the intense atmosphere of heat and bright sunlight typical of California. In this picture he applied the large, smooth areas of colour with a paint roller. The splash itself, though it appears random, was very carefully painted with small brushes, and took Hockney two weeks to complete.

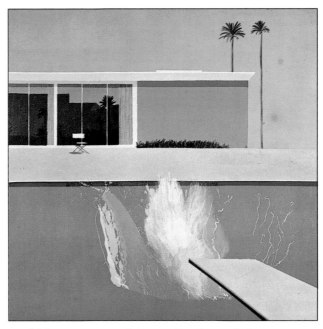

dling of paint; they found that acrylics could be diluted and applied in flat washes of intense, even colour ideally suited to the formal, hard-edged rigour of their images.

In 1953 Morris Louis began using acrylics to explore a new technique of soaking washes of diluted paint into unprimed canvas, relying on the absorbent, softening quality of the canvas weave to obtain subtle, "stained" effects. Whereas with oils it was necessary to size and prime the canvas before applying paint to prevent the oil in the paint from eventually rotting the canvas, acrylics could be applied directly without these preliminaries. Frank Stella's rigid compositions featured perfectly straight bands of intense colour with fine lines of unprimed canvas in between. To create the hard, straight edges, he applied strips of masking tape to the canvas, brushing the paint against their edges. Acrylics were ideal for this style of painting as the paint dried to a flat, even layer which disguised the activity of the brush.

On both sides of the Atlantic the 1960s saw the rise of the so-called "Pop" culture. Economic prosperity meant a surfeit of cheap, "popular" products with instant appeal, designed to be consumed immediately and thrown away after use. Artists like Roy Lichtenstein (born 1923) and Andy Warhol (1930–1987) in America and Peter Blake (born 1932) and Eduardo Paolozzi (born 1924) in Britain took as their inspiration the popular icons of the age – advertising slogans, throw-away packaging, comic-strip images, hot dogs and hamburgers – and used them in their paintings to make an ironic comment on the consumerist ethos of the time. The British artist David Hockney (born 1937) was converted to acrylics when he moved to California in 1964, finding their intense colours ideal for capturing the cloudless skies and vivid light of the West Coast.

The quality of acrylic paints has improved considerably since they were first introduced, and in recent years they have gained popularity not only with students and amateur painters but also with professional artists, some of whom previously dismissed them as an inferior alternative to oil paints. The higher pigment content, the greater flexibility of the latest resins and their longer working time now make acrylics a more serious challenge to traditional media than ever before.

MATERIALS AND EQUIPMENT

Although acrylic paints are a relatively new painting medium, most of the equipment you will need — brushes, palettes, supports, and so on — is the same as that used with traditional oil paints or watercolours. The paints may be mixed with water or combined with various mediums which alter the character of the paint, producing a range of different effects and finishes.

PAINTS

Acrylic paints are available in broadly the same traditional colours as oil paints or watercolours, as well as a few synthetic ones with unpronounceable names such as dioxazine purple and quinacridone violet, which are peculiar to acrylics. The paints are sold in tubes, jars and bottles with droppers. Which type you choose depends on the consistency of paint you prefer: tube paint is the thickest, with a consistency similar to oils; paint in jars is more creamy; and the bottled type is very fluid, ideal for covering large areas with intense, transparent washes. Acrylics are available in both "artist's" and "student's" quality. The former contain pure pigments, the latter synthetic ones.

Suggested Palette

Although the manufacturers of acrylic paints offer many inviting hues, few professional painters use more than 12 or 15. Keeping to a narrow range of colours encourages you to mix them together to create a variety of subtle hues, and results in a unified, harmonious painting. The colours described and illustrated on page 11 should meet your requirements initially; you can then expand your palette as you gain more experience.

MEDIUMS

Acrylic tube colours can be thinned with water, but they dry with a rather dull finish. However, there are various painting mediums available which give the colours brilliance and depth, improve the flow and brushability of the paint and produce a range of different effects and finishes. The mediums are milky white in appearance as they come out of the tube, but become transparent when dry.

Gloss medium thins the paint to a creamy consistency: if you add more the paint then turns transparent and allows the underlying colours to shine through, making it ideal for

SUGGESTED PALETTE

Cadmium yellow light
A bright, warm yellow. Mixes with blues to form warm yellowish greens and combines well with all reds.

Cadmium red light
A warm, intense red, very dense and opaque.

Naphthol crimson
Produces a range of violets with the blues and delicate pinks with white.

Ultramarine blue
A strong, rich blue. Mixes with yellows to form a variety of greens and with browns to form interesting greys.

Cobalt blue
A subtle blue, excellent for painting skies.

Viridian
A rich, transparent, bluish green. Retains its brilliance, even in mixes.

Titanium white
The only available white in acrylic, titanium has good covering power.

Yellow ochre
A soft yellow which is excellent for covering, mixing or glazing. Produces soft, subtle greens when mixed with blues.

Raw sienna
A warm transparent colour, excellent for glazing.

Burnt sienna
A rich, coppery red, useful for warming other colours. It is transparent and frequently used in glazes and washes.

Burnt umber
A rich and versatile brown, ideal for darkening all colours. In mixes, a little goes a long way.

Payne's grey
An opaque blue-grey with weak tinting strength. Useful for modifying other colours.

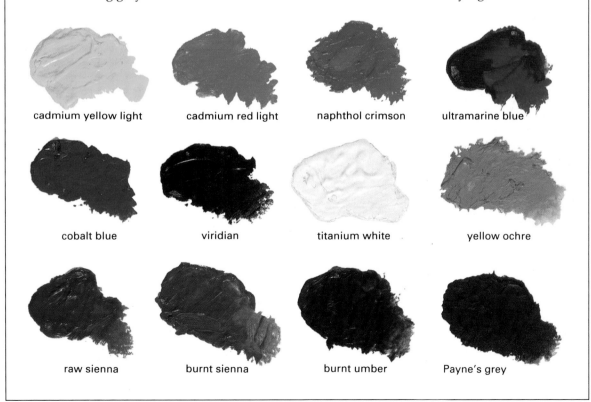

cadmium yellow light cadmium red light naphthol crimson ultramarine blue

cobalt blue viridian titanium white yellow ochre

raw sienna burnt sienna burnt umber Payne's grey

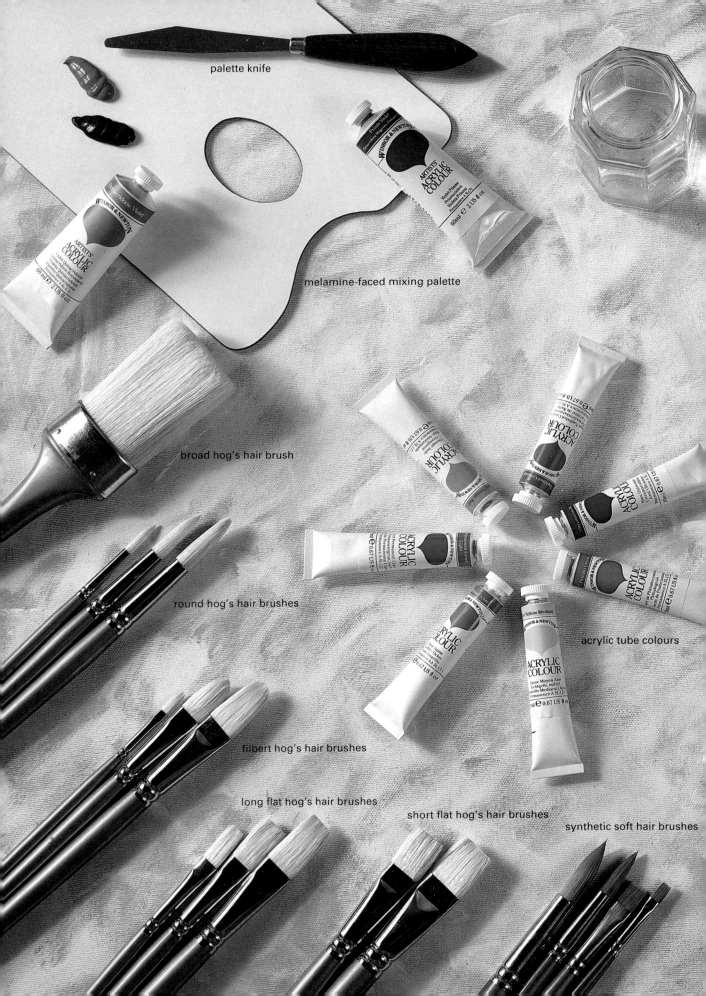

palette knife

melamine-faced mixing palette

broad hog's hair brush

round hog's hair brushes

acrylic tube colours

filbert hog's hair brushes

long flat hog's hair brushes

short flat hog's hair brushes

synthetic soft hair brushes

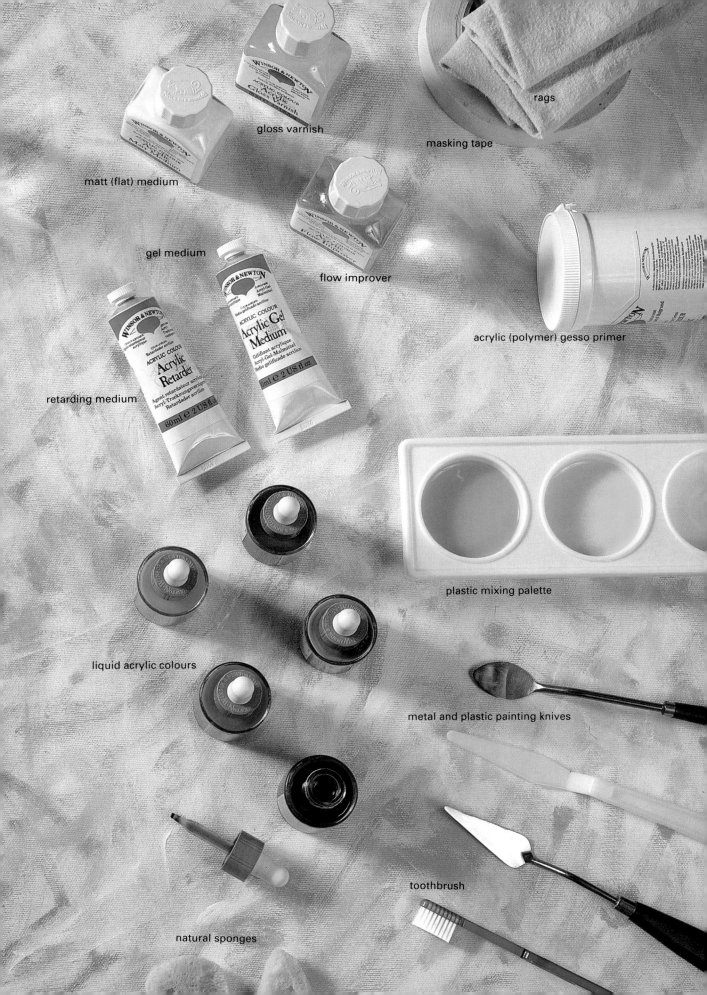

gloss varnish

rags

masking tape

matt (flat) medium

gel medium

flow improver

acrylic (polymer) gesso primer

retarding medium

plastic mixing palette

liquid acrylic colours

metal and plastic painting knives

toothbrush

natural sponges

the glazing technique (see pages 68–73). Gloss medium dries to a shiny finish like oil paintings.

Matt (flat) medium can be used in exactly the same way as gloss, but it dries to a satiny finish with no shine. Some artists find that a blend of equal parts of gloss and matt medium produces a pleasing semi-gloss effect.

Gel medium thickens the consistency of the paint to make it suitable for richly textured brush strokes, impasto effects and knife painting.

Retarding medium is a transparent substance which slows down the drying time of the paint considerably, allowing you greater freedom to move the paint around and produce softly blended effects. Mix the retarder in the ratio of one part to six for earth colours, and one part to three for other colours. If too much retarder is added, the paint will become sticky and unpleasant to use.

PRIMERS AND VARNISHES

Acrylic (polymer) gesso primer is a very thick, white liquid which can be brushed onto an absorbent surface such as hardboard (masonite) or raw canvas to provide a smooth, receptive surface to paint on (see page 16).

Once dry, acrylic paint is tough and durable and can be washed with soap and water, so a protective coat of varnish is not absolutely necessary. However, the surface of the picture can be enhanced by giving it a coat of medium or varnish, both of which are available in either a gloss or matt (flat) finish.

BRUSHES

Brushes used for oil painting are also suitable for acrylics. If the paint is to be diluted and used like watercolour, use sable or synthetic soft hair brushes, which give a smoother, softer stroke. Brushes previously used with oil paint must be carefully cleaned to remove all traces of oil from the bristles before using them with acrylics.

If you intend buying new brushes, it is worth considering the synthetic ones which have been recently developed specifically for use with acrylics. They are easier to clean than natural bristle brushes, and built to withstand the tough handling demanded by acrylics.

Most manufacturers produce around 12 sizes in any one brush series, 12 usually being the largest and 00, 0 and 1 being the smallest. The scale and style of your paintings will determine which brush sizes you choose, but as a general rule larger brushes are more versatile than smaller ones; they hold more paint and encourage a bolder approach. Paintbrushes are made in a range of shapes:

Flats have long bristles with square tips. They hold a lot of paint and can be used flat, for broad areas and washes, or on their edge for fine lines.

Brights have short, stiff bristles, giving them greater spring and control. They produce strongly textured strokes.

Filberts have slightly rounded tips that make soft, tapered brush strokes.

Rounds have long bristles, tapered at the ends. Use the body of the brush for loosely handled areas, and the tip for fine details.

Riggers have long, thin, flexible hairs. They are used for very fine linear detail such as painting the rigging on boats – hence their name.

Household paintbrushes are inexpensive and useful for applying primer and for staining the canvas prior to painting.

PAINTING AND PALETTE KNIVES

Palette knives, made of flexible steel, are used for mixing paint on the palette, while painting knives are specifically designed for applying paint to the canvas to achieve a thick impasto effect (see pages 80–87). Plastic knives are also available specifically for use with acrylics as they are easier to clean.

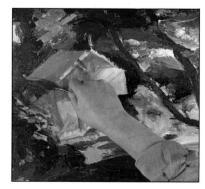

A richly textured painting surface can be built up using a painting knife to apply thick layers of paint.

An improvised version of the "staywet" palette, designed to keep paints moist during use.

PALETTES

Palettes for acrylic painting are made of plastic, which is easy to clean. A wooden palette is not recommended; the paint gets into the porous surface of the wood and is difficult to remove. Many painters prefer to use improvised palettes, especially for mixing large quantities of colour. Any smooth, non-porous material will do, such as a sheet of white laminated plastic, an offcut of hardboard (masonite) coated with acrylic primer, or a sheet of glass with white paper underneath. For mixing very fluid washes, use disposable plastic containers, paper cups or metal bun trays (muffin pans).

Acrylic paints dry out rapidly on the palette, but a special "staywet" palette is now available which keeps the colours moist for days, even weeks. It is basically a plastic tray lined with wet blotting paper, covered with a sheet of "membrane" paper. The colours are squeezed onto this and absorb moisture from the blotting paper through the membrane. Again, you can improvise your own version using a shallow plastic tray lined with blotting paper and a sheet of membrane paper (these are sold in refill packs for the "staywet" palette).

SUPPORTS

Acrylic paints can be applied to virtually any surface that is oil- and grease-free and slightly absorbent. One important point to remember is that acrylics will not adhere to any surface that contains oil or wax. Most canvas and canvas boards are now primed with an acrylic primer, but be careful not to buy those that are prepared specially for oil paint.

Canvas is normally made of linen, jute or cotton duck, and is available in fine, medium and coarse-grained weaves. If your painting style uses bold, heavy brush strokes, a coarse weave is best. For detailed brushwork and soft blending, a finely woven texture is more suitable.

Canvas can be bought ready-primed and stretched on wooden frames in various sizes. The surface of such a canvas is taut but flexible, with a pleasant receptiveness to the stroke of the brush. You can also buy unprimed canvas by the metre (yard) and stretch it yourself. Commercially pre-pared canvas boards are reasonably priced and are suitable for beginners trying out acrylics for the first time.

An excellent yet inexpensive support for acrylics is hardboard, which you can buy from builders' suppliers. Most artists use the smooth topside of the board but the reverse side is fine if you prefer a rougher texture. It is preferable to prime absorbent surfaces such as hardboard with acrylic gesso (see page 16).

Acrylics are suitable for use on cardboard, artboard or thick paper. It is best to stretch paper, especially if it is lightweight, otherwise the application of wet washes of colour will make it buckle.

MISCELLANEOUS ITEMS

You will also need a drawing board (when working on paper); jars for water; and a soft pencil for drawing. Another useful item is a hand spray of the type used for misting houseplants – spray the paints on your palette from time to time to prevent them from drying out.

Acrylics can be used on a wide variety of painting surfaces, ranging from thin paper to a tough concrete wall. Shown here are: 1 illustration board; 2 watercolour paper; 3 canvas board; 4 hardboard (masonite); 5 stretched canvas; and 6 raw canvas.

BASIC TECHNIQUES

PRIMING WITH ACRYLIC (POLYMER) GESSO

Acrylic paints can be used on either primed or unprimed surfaces, depending on the effects you seek to achieve. An absorbent surface which is unprimed, such as raw canvas, cloth or plastered walls, will absorb the pigment and dry to an even, matt (flat) finish which some artists find desirable. However, it is usual to prepare surfaces that are absorbent or dark in colour, such as hardboard (masonite), with acrylic gesso primer.

Acrylic primer is simply acrylic medium mixed with inert titanium white, but it is inexpensive to buy ready-made. Brushed onto the support prior to painting, it dries quickly to provide a matt, even surface to which the paint adheres readily. It also provides a luminously bright undercoat which enhances the colours of the painting and gives added translucence to thin washes.

Very smooth surfaces such as hardboard should first be lightly sandpapered before applying the gesso. Using a household paintbrush, apply two or three thin coats, each one at right-angles to the one before. Allow each coat to dry before the next is applied. (The gesso will dry in about 30 minutes.) For a smooth painting surface, dilute the primer to a milky consistency with water. If you prefer a more textured painting surface, use it straight from the jar (or with just a little water) and apply it with rough brush strokes. If priming illustration board, paint an equal number of coats on both sides to prevent warping. Paper does not require priming, though some artists like the smooth surface this provides.

If you do not require a white ground, but want a primed surface rather than an absorbent one, use acrylic medium which makes an excellent transparent primer.

PRIMING SUPPORTS

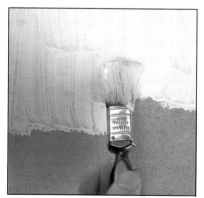

1

Apply a smooth coat of primer, working the brush in one direction only. Allow to dry.

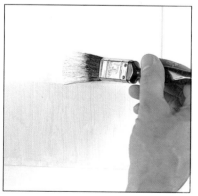

2

Apply a second coat of primer so that the strokes run at right-angles to those laid down in the first coat.

MIXING PAINT AND MEDIUM

As mentioned earlier, there are various mediums which can be added to the paint to produce particular effects. Acrylic mediums appear milky white when squeezed out of the tube, but dry transparent. Simply squeeze a small pool of medium onto your palette along with your colours. Mix the required colours together with a palette knife, then scoop up some medium and work it into the paint. If desired, the paint can be thinned further by adding water.

BRUSH STROKES

One of the great pleasures of acrylic painting is the way the paint responds to the brush. Each type of brush leaves a different kind of mark in the paint and performs a different task. With practice and experience you will learn just what each

Use a palette knife or painting knife to mix pigment and medium together on the palette.

brush is capable of and which ones suit your particular painting style.

Paint can be applied rapidly and spontaneously or slowly and methodically; in thick, short strokes and dabs or thin, transparent washes; it can be skimmed over the surface of the canvas to create lively, broken strokes in a technique known as

drybrushing, or laid on with a circular scrubbing motion to produce a thin veil of colour called a scumble.

It is important that you feel relaxed and comfortable when painting. First, position yourself so that you are able to see what you are painting as well as the canvas with minimal movement of your head. If you are painting at an easel, do not stand too close to your work; paint with your arm extended so that the movement of the arm from the shoulder, through the elbow and wrist, is fluid, confident and controlled.

Hold the brush where it feels naturally balanced, keeping your hand well back from the ferrule. Holding the brush too tightly, and too close to the ferrule, limits movement to the fingers and results in brush marks that are stilted and monotonous.

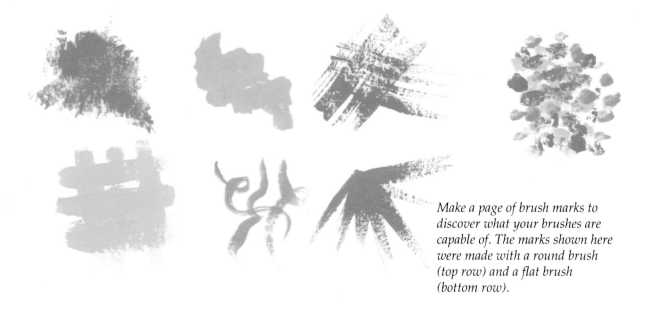

Make a page of brush marks to discover what your brushes are capable of. The marks shown here were made with a round brush (top row) and a flat brush (bottom row).

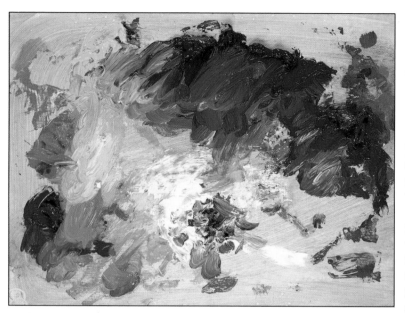

This palette layout follows the order of the spectrum with red, yellow, green, blue and violet across the top and white and neutrals beneath them.

LAYING OUT YOUR PALETTE

Arranging colours on a palette is a personal matter. It is important, however, to arrange your colours in a systematic way – and use that same orderly arrangement every time you paint, so that you know where each colour is without having to look. Squeeze the colours onto the palette in generous mounds. Beginners tend to squeeze out little blobs of colour in haphazard fashion, and end up wasting a lot of time trying to find the spot of colour they need and constantly screwing and unscrewing the caps of the paint tubes.

Some artists like to lay out their colours in the order of the spectrum with red, orange, yellow, green, blue and violet across the palette and earth colours down the side. Others prefer to align warm colours

(the reds, oranges and yellows) and cool colours (the greens, blues and violets) on opposite sides of the palette.

PRECAUTIONS

The speed at which acrylics dry is one of their major attractions, but the drawback is that they dry equally quickly on palettes and brushes – and once dry they are impervious to water. With care and a little ingenuity, however, this need not be a problem.

To prevent paint drying on your brushes during a painting session, keep them in a jar of clean water whenever you are not using them. It is even better to lay them flat in a shallow tray of water – that way the bristles will not get distorted. All you need is a plastic tray – the type oven-ready meals come in; cut a notch in one end for the brush handles to rest on. Always be sure to moisten

your brushes with water *before* loading them with acrylic paint; otherwise the paint will stick to the dry bristles and gradually build up a stiff film that ruins them.

After use, brushes should be rinsed thoroughly in clean water. To remove paint from the neck of the brush, where the hairs enter the metal ferrule, stroke the brush gently across a bar of soap. Then lather the bristles in the palm of your hand with a gentle circular motion until the last trace of colour comes out in the lather. Rinse again, then shake out the water and re-shape the bristles with your fingers. Leave the brushes to dry upright in a jar.

If brushes do become caked with paint, soak them overnight in methylated spirit. This

During a painting session, keep brushes immersed in water to prevent paint drying on the bristles. A shallow tray like this one will also prevent distortion of the bristles.

should loosen the paint sufficiently for it to be worked out under running water. Then wash the brushes in mild soap and warm water.

To prevent paints from drying out on the palette, spray them periodically with a mist of water. Special "staywet" palettes are available which keep paints moist for days (see page 15). Use plastic palettes for ease of cleaning, and wash them immediately after use. If paint becomes caked on the palette, leave it to soak in warm water for an hour and then peel or scrape it off.

At the end of the painting session, it is worth making the effort to wipe the tube caps and the screw heads with a damp cloth; otherwise the dried paint will make it difficult to remove the caps next time you paint. (If tube caps are stuck, they can usually be loosened by pouring hot water over them.)

Once dry, acrylic paint is almost impossible to remove from any absorbent surface, so take the precaution of wearing old clothes and shoes when working, and protect surrounding surfaces with sheets of newspaper.

SQUARING UP

You may wish to base an acrylic painting on a sketch or photographic image; but it is often difficult to maintain the accuracy of the drawing when enlarging or reducing a reference source to the size of your canvas or paper. A simple method of transferring an image in a different scale is by squaring up (sometimes called scaling up).

Using a pencil and ruler, draw a grid of equal-sized squares over the sketch or photograph. The more complex the image, the more squares you should draw. If you wish to avoid marking the original, make a photocopy of it and draw the grid onto this. Alternatively, draw the grid onto a sheet of clear acetate placed over the original, using a felt-tip pen.

Then construct an enlarged version of the grid on your support, using light pencil lines. This grid must have the same number of squares as the smaller one. The size of the squares will depend on the degree of enlargement required: for example, if you are doubling the size of your reference material, make the squares twice the size of the squares on the original reference drawing or photograph.

When the grid is complete, transfer the image that appears in each square of the original to its equivalent square on the support. The larger squares on the working sheet serve to enlarge the original image. You are, in effect, breaking down a large-scale problem into smaller, manageable areas.

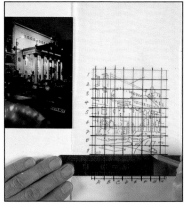

1
Make a sketch from the reference photograph and draw a grid of squares over it.

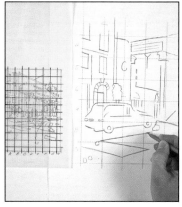

2
Draw a grid of larger squares onto the support and transfer the detail from the sketch, square by square.

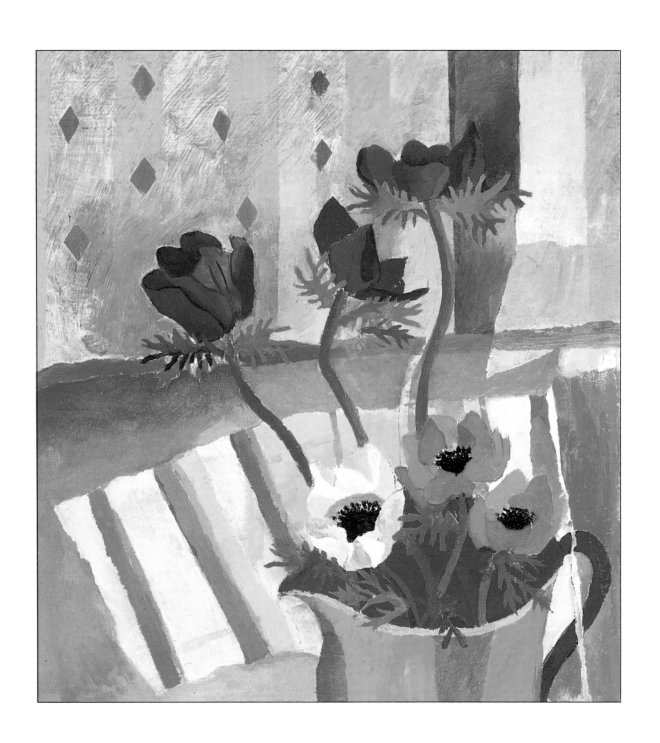

GALLERY

Art – whether painting, music or dance – is a symbiotic relationship between technical skill and originality of vision. While it is true that technical excellence alone will not produce great art, it is also true that knowledge of the basic skills and techniques is the "language" which enables the artist to express his or her personal vision with confidence.

The following pages illustrate the work of several contemporary painters in acrylic. As well as revealing the immense versatility of this exciting medium, these works reflect the diversity of the artists' creative vision. Having learned the basic techniques of acrylic painting, you should feel encouraged to explore the medium further, and to use it to express what you have to say.

~

Anemones

Katie Scampton

25 x 23cm (10 x 9in)

Colour and pattern are the dominant themes in this semi-abstract still life. Torn and cut pieces of masking tape have been used as stencils to achieve the sharp, graphic quality of the patterned elements, and also to define some of the leaves and petals.

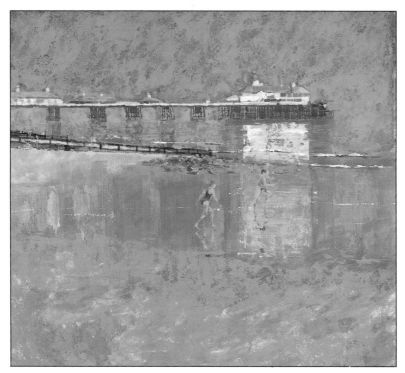

The Beach at Eastbourne

Terry McKivragan

74 x 74cm (29 x 29in)

Subtle and atmospheric, this painting has qualities more usually associated with oils than with acrylics. This is achieved by building up the colours in thin, smoky layers rather than solid blocks of colour. McKivragan starts off with thin washes and applies increasingly thicker layers of paint, allowing the previous layers to come through. The final colours are gently dragged with a painting knife, giving the paint surface an attractive, almost pastel-like quality.

St Martin's

Gary Jeffrey

56 x 67cm (22 x 26½in)

For Jeffrey, the quality of the paint surface is an important element in the painting. He works on thick cartridge (drawing) paper primed with shellac, which not only provides a warm tone on which to paint but also seals the surface. The paint can be moved around on this smooth, non-porous ground, allowing interesting textures and brush marks to be built up.

Near Marrakesh

Roy Perry

22 x 30cm (8½ x 12in)

Working on watercolour paper primed with acrylic gesso, Perry has used a limited palette of blues and earth colours for this quiet pastoral scene. The brushwork overall is smooth, with textural interest provided by the delicate touches of drybrush used to suggest the trees, the foreground grass and the rough track leading to the village.

Rustic Study II

Phil Wildman

41 x 51cm (16 x 20in)

Both acrylic paint and acrylic medium are adhesive, and this makes them ideal for collage work. For this semi-abstract image Wildman used a combination of thin washes of acrylic paint and layers of tissue paper, both flat and crumpled, to build up an interesting surface texture which is appropriate to the subject.

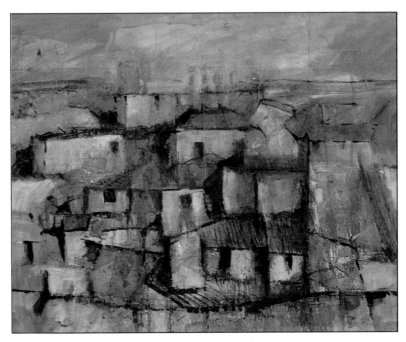

The River Avon

Valerie Batchelor

15 x 23cm (6 x 9in)

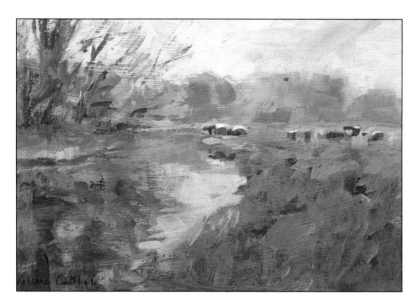

Batchelor's paintings are impressionistic, her main concern being to capture the quality of the light on her subjects. She works on smooth paper or board primed with gesso, and always starts by brushing a thin layer of colour – one which contrasts with the dominant colour of the picture – over the support. Here, for example, the ground colour is a warm red. Small patches of the ground remain exposed throughout the picture, their warm colour helping to unify the composition and contrasting with the cool greens and greys.

Provençal Landscape

Ted Gould

64 x 76cm (25 x 30in)

A hillside villa, surrounded by olive trees, provided attractive inspiration for this painting. The influence of Cézanne is evident here: like Cézanne, Gould uses planes of colour to define forms and exploits the visual phenomenon whereby warm colours (reds and yellows) appear to advance, while cool colours (blues and greens) seem to recede. The picture strikes a beautiful balance between realism and abstraction, the repeated arabesques of the paint marks emphasizing the painting's surface unity.

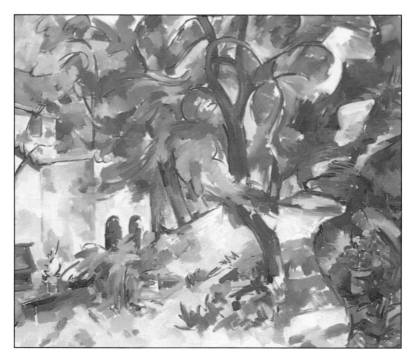

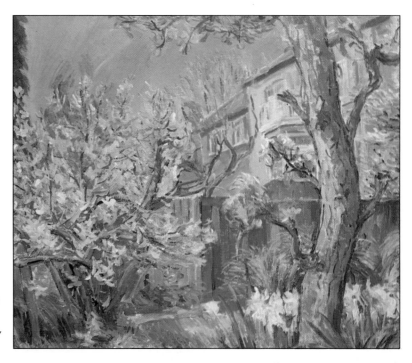

Springtime Garden

Ted Gould

51 x 61cm (20 x 24in)

The fresh, sparkling quality of spring sunshine is beautifully recreated in this painting of a corner of the artist's garden. The broad colour areas were first blocked in with thin colour, overlaid with dabs and strokes of thick, pure colour in the trees and grass. The high-key colour scheme of complementary colours – blue and yellow – creates a scintillating, light-filled image.

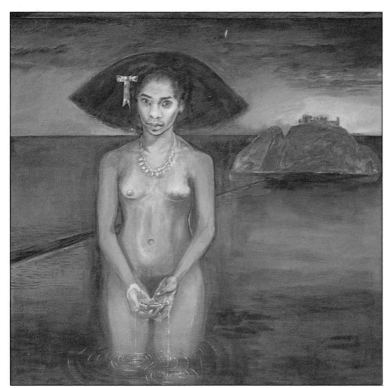

The Girl from the Tower

Barbara Tyrrell

81 x 81cm (32 x 32in)

Everything about this picture — the composition, the way colours and tones are balanced against each other, and the way the paint is applied — contributes to its haunting quality. The luminous depth of the colours is achieved by superimposing multiple glazes of transparent paint.

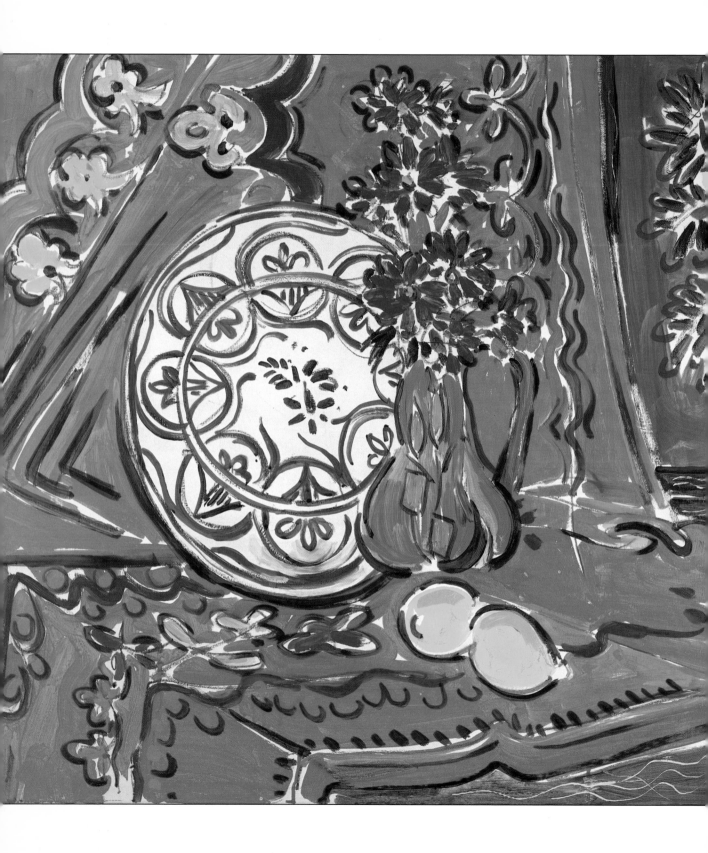

PAINTING "ALLA PRIMA"

The French painter Henri Matisse (1869-1954) once declared that "to copy the objects in a still life is nothing. One must render the emotions they awaken."

Matisse's ideas on the use of colour and design to translate the artist's feelings about a subject are evident in this painting. Speed, fast attack and brilliant colour are the keynotes of this work, which expresses the artist's joy in colour and the very act of painting.

The picture was painted in the alla prima manner – that is to say, completed in one session, without any preliminary underpainting. Working alla prima requires confidence, but it is very liberating – the idea is to work rapidly and intuitively, using the brush freely to express your instinctive response to your subject.

~

Kay Gallwey
Still Life
76 x 76cm (30 x 30in)

~

ALLA PRIMA TECHNIQUE

An Italian expression, *alla prima*, meaning "at the first", describes a painting which is completed in a single session. It also describes a direct method of working, in which each brush stroke is applied decisively and left alone; the colours are applied directly onto the painting surface, often without a preliminary under-drawing or underpainting.

Acrylic paints are ideally suited to this type of painting because they can be used thickly – straight from the tube – or diluted with water for wash-like effects. And because they dry so quickly, you can apply one colour over another within just a few minutes, without fear of disturbing the colour beneath.

An alla prima painting normally has a certain amount of untouched white canvas, because the brush strokes are applied freely without modification or any attempt at preci-sion. (This can be seen in the demon-stration painting which follows.) The combination of expressive brushwork and glints of unpainted canvas gives the painting a verve and energy which is very appealing; just as a quick sketch often has more immedia-cy and vigour than a fully worked drawing, so an alla prima painting can convey the artist's emotional response to a subject better than a more deliberate studio painting.

Alla prima painting requires a con-fident approach, so it is important to start out with a clear idea of what you want to convey in your painting and dispense with inessential elements which do not contribute to that idea. It is best to stick to a limited range of colours so as to avoid complicated colour mixing which might inhibit the spontaneity of your brushwork.

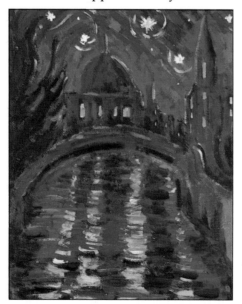

Thick paint and rapid, swirling brush strokes were used to highlight the dreamlike quality of this painting. The fast-drying quality of acrylic paint allows successive layers of colour to be applied without disturbing those beneath.

STILL LIFE

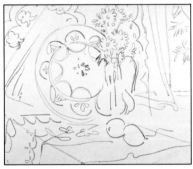

Left: This is a very simple still-life group, but the objects were carefully chosen so that the artist could exploit their bright colours and decorative patterns.

Materials and Equipment

• SHEET OF CANVAS, CANVAS BOARD, OR HARDBOARD (MASONITE) PRIMED WITH ACRYLIC PRIMER • ACRYLIC COLOURS: NAPHTHOL CRIMSON, CADMIUM SCARLET, AZO MEDIUM YELLOW, HOOKER'S GREEN, LIGHT GREEN OXIDE, COBALT BLUE, PRISM VIOLET, CADMIUM ORANGE AND RAW UMBER • SOFT HAIR ROUND BRUSH • BRISTLE BRUSHES: LARGE AND MEDIUM-SIZED

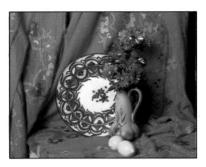

1

Sketch out the main outlines of the composition using either thinned paint and a round soft hair brush, as here, or a stick of charcoal. Soft charcoal allows you to erase mistakes, but you should "knock back" the drawn lines by rubbing away the excess charcoal dust with a cloth to prevent it from mixing with the paint and muddying the colours.

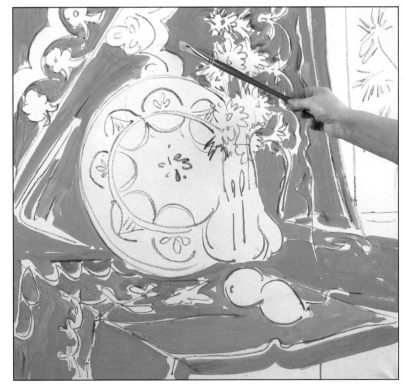

2

Mix together naphthol crimson and cadmium scarlet and dilute to a fairly thin consistency with water. Use a large flat bristle brush to block in the red backcloth. Leave the patterned areas of the cloth, and the "window", unpainted.

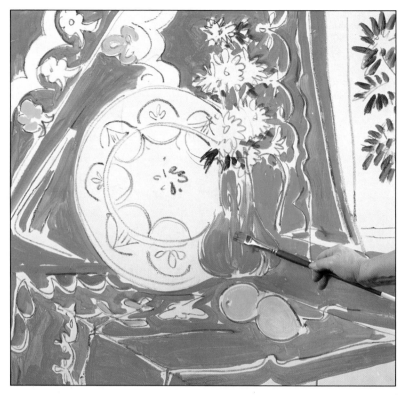

3

Paint the two lemons with azo medium yellow leaving a sliver of white canvas just inside the drawn outlines. With the same colour, block in the yellow floral pattern on the backcloth. Paint the flower foliage and the leaves in the window with Hooker's green. Roughly block in the vase with light green oxide, overlaid with Hooker's green in the darker parts.

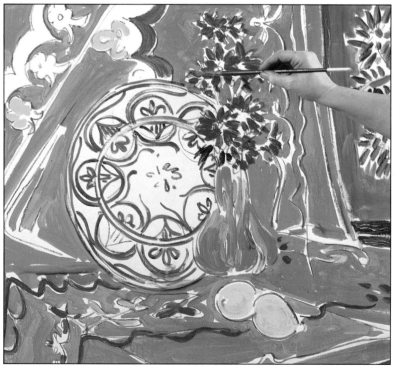

4

Paint the pattern on the plate with thin cobalt blue and a medium-sized flat bristle brush. Quickly wash in the sky outside the window with cobalt blue and white. Mix prism violet and cobalt blue for the flowers in the vase and the blue pattern on the backcloth. Suggest the pattern on the vase with quick strokes of cadmium orange.

5

Paint the visible areas of the wooden table top with thinly diluted raw umber. Before the paint dries, draw undulating lines into it quickly with your thumbnail. This gives a suggestion of wood grain and also adds to the decorative effect of the painting.

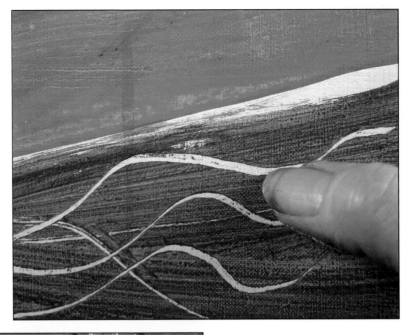

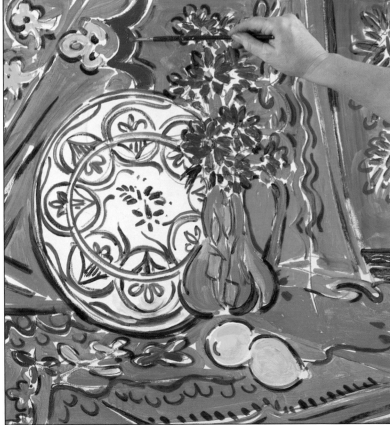

6

Add curving strokes of cadmium orange to the tops of the lemons to give a suggestion of form. Finally, use fairly diluted cobalt blue and prism violet to complete the linear details of the painting such as the pattern on the vase and the linear pattern, folds and creases on the backcloth.

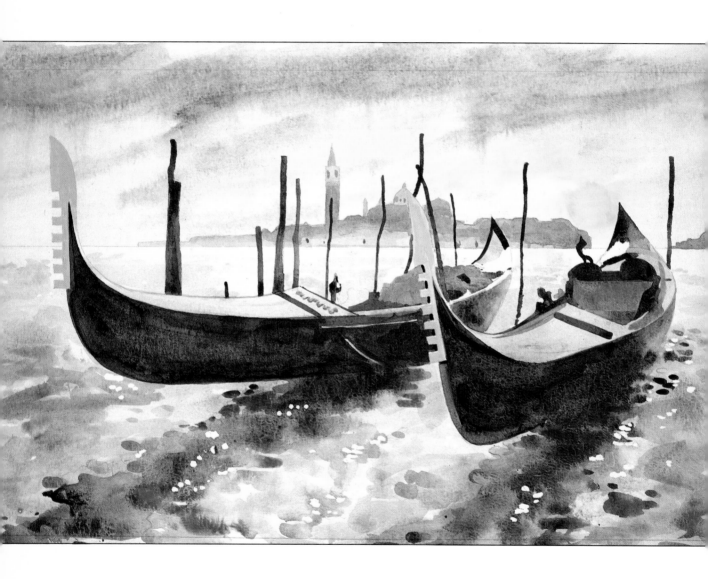

Technique
2

THE TRANSPARENT TECHNIQUE

Acrylic paint can be used in thin washes to produce an effect which is almost indistinguishable from traditional watercolour. In this acrylic painting of gondolas moored in Venice's Grand Canal, the artist has worked on a heavy, rough-textured watercolour paper using typical watercolour techniques. The diffuse colours of the sky are portrayed with wet washes, blended softly together on the damp paper. The water, too, is painted wet-into-wet; the sparkling highlights in the foreground were first stopped out with masking fluid to preserve the white of the paper, allowing the artist to paint freely over them. The finished painting suggests the hazy, watery quality of the light just after a rainstorm.

~

Phil Wildman
Two Gondolas
33 x 51cm (13 x 20in)

~

USING TRANSPARENT WASHES

When acrylic paints are diluted with enough water and/or medium they behave in a way similar to traditional watercolours, producing delicate washes through which the whiteness of the paper or canvas shines, enhancing the luminosity of the colours.

One of the great advantages of acrylic over watercolour, however, is that once the colour is dry, acrylic is insoluble and permanent. This means that successive washes of transparent colour can be applied without disturbing the underlying colours.

Another problem with watercolour is controlling a wash so that the colour is evenly distributed, but when working with acrylics this problem can be solved by adding a brush-load of matt (flat) or gloss medium to a wash. This thickens the paint just enough to help it roll smoothly onto the paper or canvas. Brush strokes hold their shape better when applied with medium and water rather than water alone, and are easier to control.

Some artists might claim that the quick-drying properties of acrylic make it difficult to apply fluid washes wet-into-wet in the watercolour manner. In fact, watercolours, too are quick-drying; the problem – in watercolour as in acrylics – arises when the inexperienced artist fusses and prods at the paint, muddying the colours and ruining the limpid, translucent beauty that is the hallmark of all water-based media. Fluid washes should be applied swiftly and confidently and left alone – so drying times should not be a worry.

When using acrylic as watercolour you can use either soft hair or bristle brushes, but for the best results use soft hair ones as these hold more paint and produce smoother strokes. Acrylic washes can be applied on canvas, canvas board or smooth illustration board, and all the traditional watercolour papers are suitable, though it is best to use heavier papers as the lightweight ones tend to buckle when wet.

It is a good idea to tilt your drawing board at a slight angle so that the colour runs downwards and any excess can be mopped up at the bottom of the area you are covering.

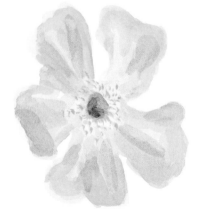

Acrylic paint is often regarded as a bright, brash medium. Yet when thinly diluted and used like watercolour paint it is capable of suggesting even the most delicate flower petal.

TWO GONDOLAS

Materials and Equipment

• SHEET OF HEAVY GRADE, ROUGH-SURFACE WATERCOLOUR PAPER • HB PENCIL • OLD WATERCOLOUR BRUSH FOR APPLYING MASKING FLUID • MASKING FLUID (LIQUID FRISKET) • SOFT HAIR BRUSHES: LARGE FLAT; MEDIUM AND SMALL ROUNDS • ACRYLIC COLOURS: PAYNE'S GREY, YELLOW OCHRE, LEMON YELLOW, BRIGHT GREEN, ULTRAMARINE BLUE, RAW UMBER AND BURNT SIENNA • PLASTIC ERASER

1

Make a light outline drawing of the composition in pencil.

2

As in watercolour, the white of the paper will provide the brightest highlights – the sparkling reflections of the sun on the water's surface. Begin by painting these with small dabs of masking fluid (liquid frisquet), using an old watercolour brush. This water-resistant mask will preserve the white of the paper while allowing you to apply washes freely over the area. Allow a few minutes for the masking fluid to dry.

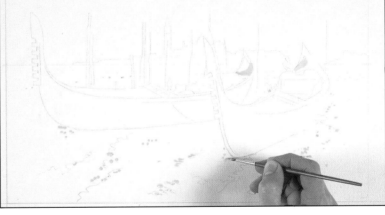

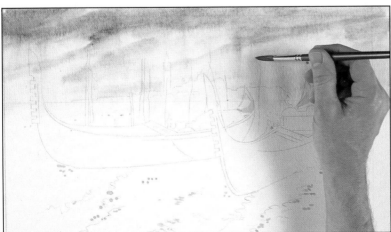

3

Tilt the board at a slight angle and use a large flat soft hair brush to wet the sky area with clean water. Mix Payne's grey with a little yellow ochre and lay in diagonal streaks of this colour with a medium round brush. Then apply strokes of very diluted lemon yellow for the sunlit clouds. Allow the colours to bleed softly together to create a hazy effect. The colour should be strongest at the top of the sky, grading down almost to nothing on the horizon, to give the illusion of the sky receding into the distance.

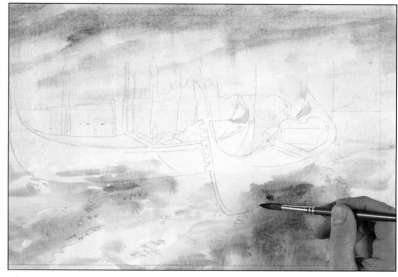

4

Mix bright green, ultramarine blue and lemon yellow and dilute to a pale wash. Quickly brush this over the water. Mix a darker green from Payne's grey, ultramarine blue and lemon yellow and, before the first wash dries, paint the darker parts of the waves. Leave to dry.

5

Mix ultramarine blue and raw umber to a very pale tint. Using a small round brush, fill in the outlines of the buildings in the distance. Let the paint dry slightly, then apply a wash of diluted burnt sienna over the darker parts of the buildings. Lighten the tone with more water for the buildings in the further distance.

6

Mix a stronger tone of ultramarine blue and raw umber and use this to strengthen the darkest parts of the buildings and dot in a suggestion of windows and doors.

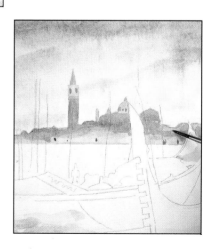

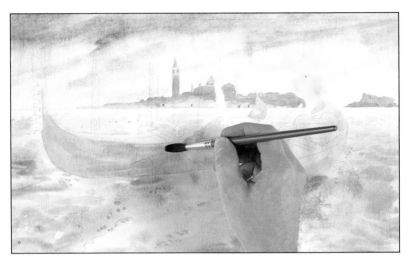

7

Mix Payne's grey and yellow ochre to a pale tint and wash this over the hulls of the gondolas with a medium-sized round brush. Use the same colour to paint the ripples in the water behind the gondolas with small strokes, and strengthen the darks in the water in the immediate foreground.

8

Paint the seat inside the gondola with burnt sienna. Paint the wooden poles in the foreground with a small round brush and a mixture of raw umber and a touch of Payne's grey. Use slightly thicker paint here to create a denser tone.

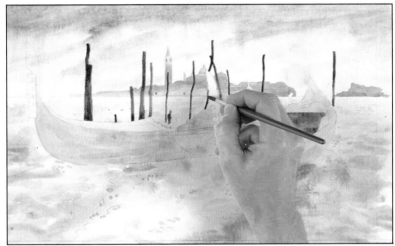

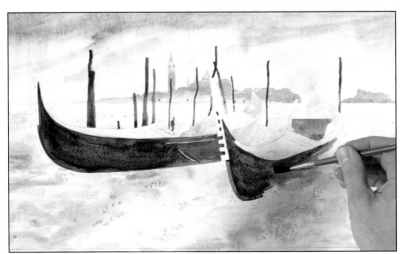

9

Mix Payne's grey and ultramarine to make a very dark tone and paint the hulls of the gondolas with the medium-sized round brush, leaving the tops unpainted as these reflect light from the sky and are much lighter in tone. Model the rounded forms of the boats by graduating the tone from light to dark.

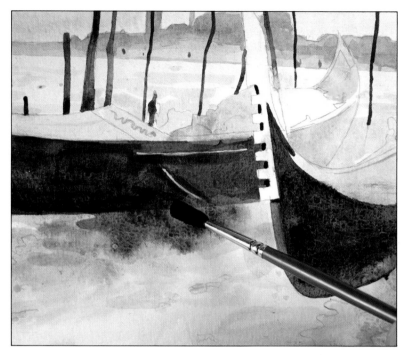

10

As you work on the boats, bring the colour right down into the water beneath the boats and begin to indicate their reflections in the water. This helps to give the impression that the boats are sitting in the water rather than resting on top of it.

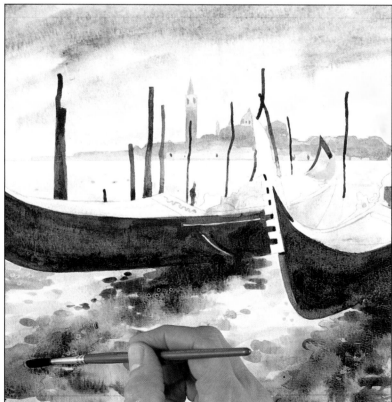

11

While the dark, bluish boat reflections are still wet, develop the greenish tints in the water with a mixture of lemon yellow, ultramarine blue and Payne's grey. While this is still wet, drop in some neat Payne's grey here and there. Allow the colours to merge softly together wet-into-wet to give an impression of the gently undulating movement of the water.

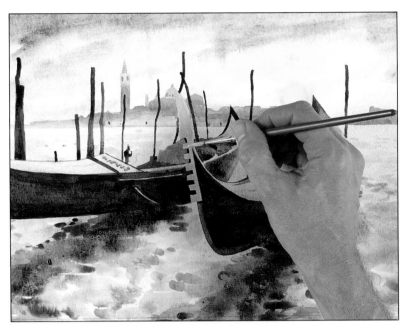

12

Using a small round brush carefully fill in the indented shapes of the ornamental prow and the platform at the stern of each gondola with a silvery colour mixed from titanium white and a hint of Payne's grey. Then mix Payne's grey and raw umber for the dark parts of the seats. Paint the green tarpaulin with a mixture of bright green and yellow ochre. Leave the painting to dry completely.

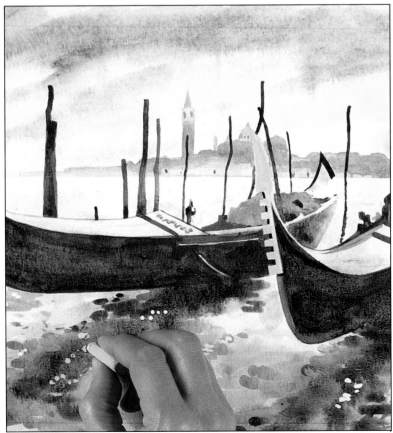

13

Remove the masking fluid by rubbing gently with the corner of a plastic eraser (or a fingertip). The light-reflecting surface of the paper is very effective in representing light shimmering on the water.

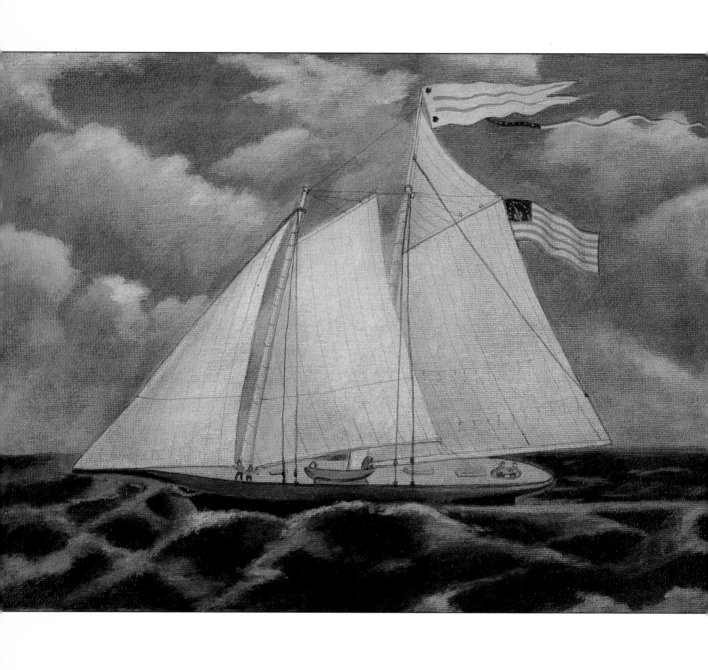

Technique

3

A NTIQUING

Traditionally, oil paintings are varnished to protect the surface from dust and to restore the colours, which tend to darken as the paint dries. Over the course of many years the varnish itself darkens and gives an oil painting that mellow glow which we associate with Old Master paintings.

Acrylic paints do not crack or fade, and the surface can be washed with soap and water, so varnishing is not strictly necessary. However, it is possible to give an acrylic painting an "antique" look – within minutes of completing it – by applying a coat of tinted varnish and then rubbing it off to leave a residue behind.

The effects of making a new painting appear old can be seen in this charming seascape, which is copied from a painting called *The Schooner Yacht America* by the American folk artist, James Baird (1815-1897).

~

Josephine Whitfield
The Schooner
25 x 36cm (10 x 14in)

~

ANTIQUING TECHNIQUE

Acrylics are the most modern of artists' paints, so naturally they tend to be associated with the bright, brash, hard-edged painting style used by the Pop artists of the 1950s and '60s. Yet such is the versatility of acrylics that they are also capable of reproducing the subtle effects of traditional oil and watercolour paintings. As this project shows, you can make an acrylic painting look like an oil painting which has darkened with age.

Antiquing is very simple to do, but the results are very attractive. All you need is some household polyurethane tinted varnish (gloss or matt/flat) in a dark colour such as dark oak or antique pine. Make sure your finished painting is completely dry, then use a household paintbrush to apply a thin coat of varnish over the entire surface. There is no need to apply the varnish smoothly – brush it on quickly as it must remain wet for the next stage in the process.

Now use a clean, soft, lint-free cloth to rub the surface of the painting briskly with a circular motion to remove some of the varnish, leaving a thin stain behind. Magically, this thin wash of varnish gives the painting a mellow patina of age, at the same time enriching the colours beneath. Clean your brush immediately in white spirit (paint thinner), and leave the painting to dry for a few hours.

THE SCHOONER

1 Use a soft pencil to outline the main shapes in the composition.

Materials and Equipment

• SHEET OF SMOOTH CANVAS, CANVAS BOARD OR PRIMED HARDBOARD (MASONITE) • HB PENCIL • ACRYLIC COLOURS: ULTRAMARINE BLUE, RAW UMBER, TITANIUM WHITE, YELLOW OCHRE, EMERALD GREEN, BURNT UMBER, PRUSSIAN BLUE, BURNT SIENNA AND CADMIUM RED MEDIUM • SOFT HAIR BRUSHES: 13MM (1/2IN FLAT); SMALL AND MEDIUM-SIZED ROUNDS • RIGGER BRUSH • TIN OF HOUSEHOLD GLOSS VARNISH IN A DARK COLOUR, SUCH AS DARK OAK • 7.5CM (3IN) FLAT SOFT HAIR BRUSH OR HOUSEHOLD PAINTBRUSH • LINT-FREE CLOTH

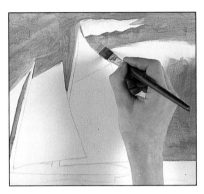

2

Mix a greyish blue from ultramarine blue with a hint of raw umber to tone down the colour. Dilute with water to a thin consistency. Block in the undertone for the sky with a 13mm (1/2in) flat soft hair brush, working carefully around the shapes of the boat's sails.

3

Use the same brush to paint the sails with titanium white toned down with a touch of yellow ochre. Use slightly thicker colour here.

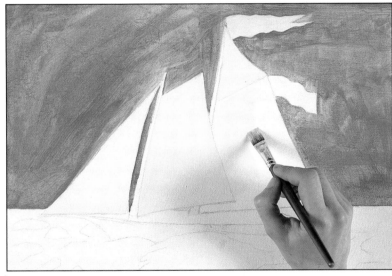

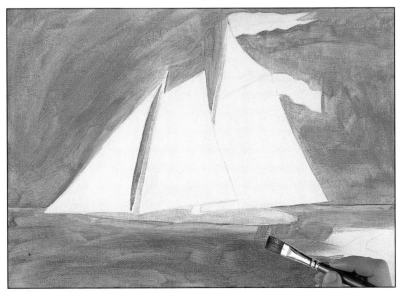

4

Paint the deck and masts with a thin wash of yellow ochre and titanium white. Wash the flat brush thoroughly and use it to paint the undertone of the sea with a thin wash of emerald green. Use the brush freely to give a sense of movement to the water.

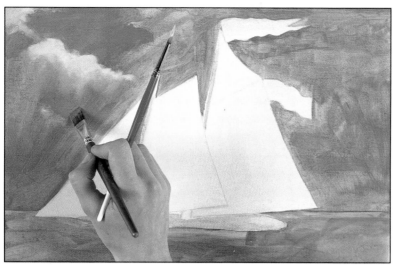

5

Start painting the soft cumulus clouds using thin, dryish paint to create an airy effect. For the dark grey areas use the flat brush and the same mixture as in step 2 but with a thicker, more creamy consistency. For the white tops use a medium-sized round soft hair brush and titanium white. Apply the grey and then the white, then use the brush to softly blend the colours together where they meet to create a half-tone in between.

6

Work on one cloud at a time so that you can blend the colours softly before the paint dries. Also soften the outer contours of the clouds by rubbing them into the weave of the canvas, to create a sense of atmosphere and prevent the clouds from appearing "pasted on" to the sky.

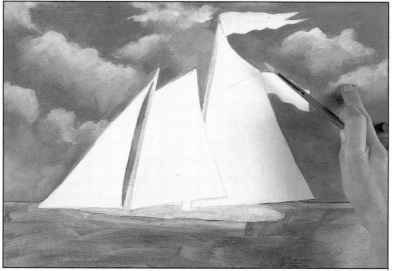

7

Continue working on the clouds, making sure that they are largest near the top of the picture, becoming gradually smaller as they near the horizon so as to give the effect of receding space. To create very soft gradations of tone in the clouds, use a fingertip to blend the greys and whites together.

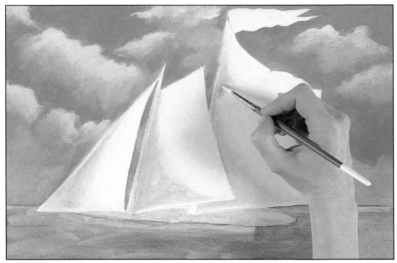

8
Mix a very pale tone of burnt umber and titanium white and paint the shadows on the sails and flags with a medium-sized round soft hair brush.

9
With the same brush paint the lower half of the boat's hull with emerald green darkened with Prussian blue and a little raw umber. Use the same colour to paint the dark areas of the waves with curving strokes.

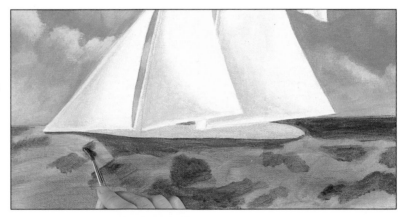

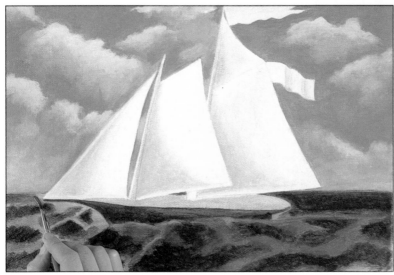

10
While the paint is still wet, quickly block in the mid-tones in the waves with emerald green and a touch of titanium white, blending the dark and mid-tones together in places. Also paint the upper half of the boat's hull.

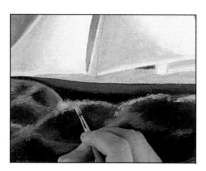

11

Wash the brush, then paint the crests of the waves with tiny strokes of white toned down with just a hint of emerald green, reserving pure white for the highlights.

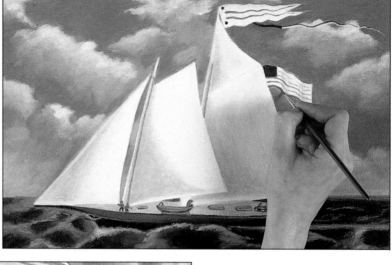

12

Paint the figures and detailing on the deck with a small round soft hair brush. Use burnt sienna, cadmium red medium and Prussian blue for the figures and emerald green and titanium white for the lifeboat. Paint the patterns on the flag and pennant with cadmium red medium and Prussian blue.

13

Mix burnt umber and titanium white and dilute to a thin consistency. Use a rigger brush to paint the thin vertical lines on the sails. You will need a steady hand for this, but the lines must not be too mechanical so don't use a ruler! You may find it easier to turn the painting around and draw the lines in a horizontal rather than vertical direction.

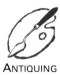

14

Now use the rigger to outline the sails and paint the rigging with slightly thicker lines of burnt umber. Again, turn the painting around if you find it easier to paint the lines in a horizontal direction. Leave the painting to dry thoroughly.

15

Apply a thin coat of dark gloss varnish over the entire painting using a 7.5cm (3in) flat soft hair brush or a household paintbrush. Work quickly because the varnish must remain wet for the next stage.

16

Rub vigorously over the entire canvas with a clean, lint-free cloth. This removes most of the varnish, at the same time pressing some of it into the weave of the canvas so as to leave a light stain of warm colour.

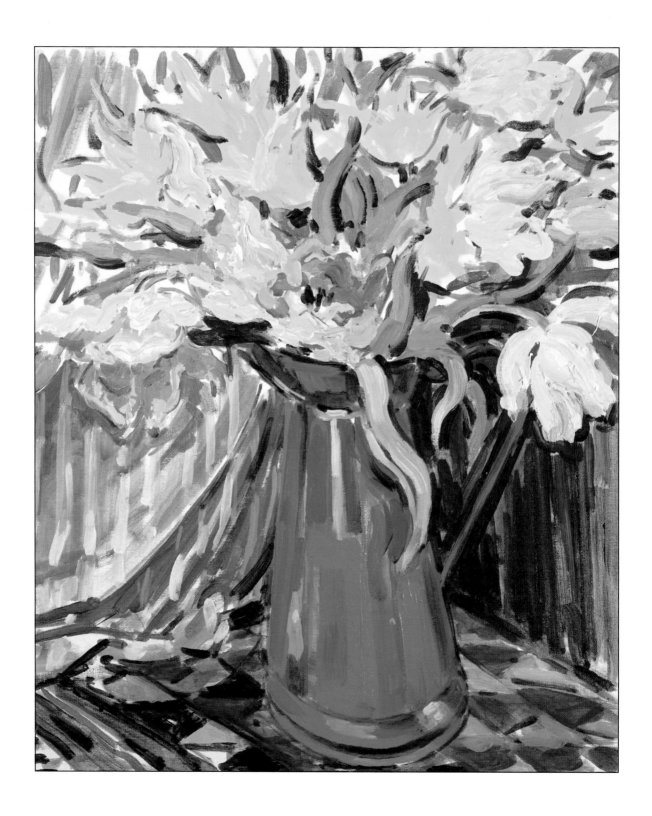

IMPASTO

Impasto – thick, heavily textured paint – is most commonly associated with the direct, or "alla prima", style of painting, in which a picture is completed in one session, without a preliminary underpainting. Thick paint and rapid brush strokes allow the picture to be built up quickly and in a spontaneous manner, and this approach was adopted by the artist in this painting of a jug full of tulips. Thick layers of undiluted paint were applied directly onto the canvas, "sculpting" the pigment with a bristle brush to heighten its textural quality. The result is a highly tactile painting which emphasizes the strong forms of the flowers and foliage.

Kay Gallwey
Tulips
61 x 51cm (24 x 20in)

IMPASTO TECHNIQUE

Thick paint, heavily applied to the canvas so that it has a rough, uneven texture, is called impasto. In contrast to glazing – the methodical building up of thin layers of paint – impasto involves using the paint thickly, liberally and in a bold, direct manner. It is not a technique for the faint-hearted, but most artists enjoy the expressive and textural qualities that impasto can lend to a painting. Van Gogh's vibrant paintings, with their thick, swirling brush strokes are a classic example of this approach.

Impasto can be applied with a brush, a painting knife or a combination of the two. Use the paint straight from the tube, or diluted with just a drop of water so that it is malleable, yet thick enough to retain the marks and ridges left by the brush or knife. If you wish, the paint can be further stiffened by mixing it with gel medium, which will help the paint to retain the marks of the brush.

Flat bristle brushes are best for impasto work because they hold a lot of paint. Load the brush with plenty of colour and dab it onto the canvas, working the brush in all directions to create a very obvious, almost sculptural effect. The adhesive and quick-drying properties of acrylics mean that they can be used very thickly and yet will dry in a few hours, without fear of cracking.

An impasto painting should look free and spontaneous, but it actually needs careful planning. Just as colour loses its vitality when it is too thoroughly mixed on the palette, directly applied paint quickly loses its freshness when the pigment is pushed around on the canvas for too long. In any case, acrylic paint does not lend itself to being moved around once it is on the canvas because it dries so quickly. When using acrylics thickly you must decide in advance the position, direction and thickness of each stroke. Be sure your brush carries a liberal amount of paint, apply it with a clear sense of purpose, and then leave it alone.

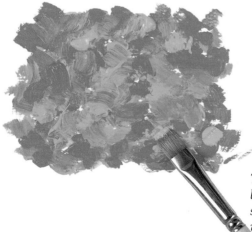

To create a textured impasto, load a bristle brush with paint and make short, heavy strokes worked in all directions to create a very obvious, almost sculptural effect.

TULIPS

Right: These parrot tulips were chosen for their warm strong colours and textural petals and leaves. A simple setting and plain blue jug enhance the exuberant beauty of the flowers.

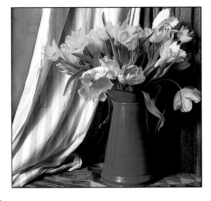

1

Sketch out the composition with thin diluted paint, using blues, yellows and browns to establish the basic colour scheme. "Draw" the lines with a medium-sized flat bristle brush. The underdrawing is only a rough guide – any necessary adjustments can be done later.

2

Still using thin paint, start to establish the major tones and colours. With a large flat bristle brush, rough in the tones of the blue jug with broad strokes of brilliant blue and cobalt blue. Suggest the folds in the blue backcloth with titanium white and a touch of brilliant blue. Use raw umber and quinacridone violet for the dark backcloth and the patterned kilim on which the jug rests. Paint the yellow tulips with azo medium yellow, and the lightest parts of the orange-red tulips with azo medium yellow and cadmium yellow deep.

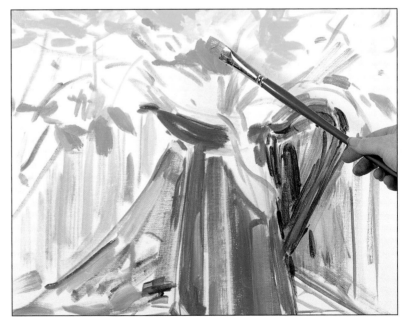

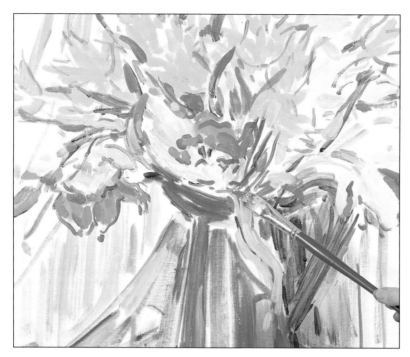

3

Using thicker paint, diluted with just a little water, paint the deepest tones on the orange-red tulips with various reds – cadmium scarlet, naphthol crimson and quinacridone violet. Paint the leaves of the tulips with thick, sinuous strokes using Hooker's green for the darkest tones, light green oxide for the medium tones and citrus green for the lightest tones, mixing all of these colours with titanium white.

4

Strengthen the tones on the blue jug and backcloth with thick paint, using brilliant blue and titanium white for the lights and cobalt blue for the darks. Paint the diamond pattern on the kilim using quinacridone violet, naphthol crimson, cadmium orange, mars black and brilliant blue mixed with white.

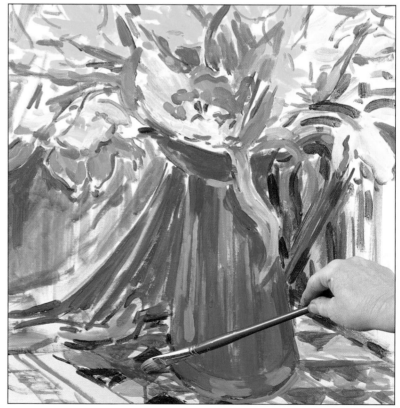

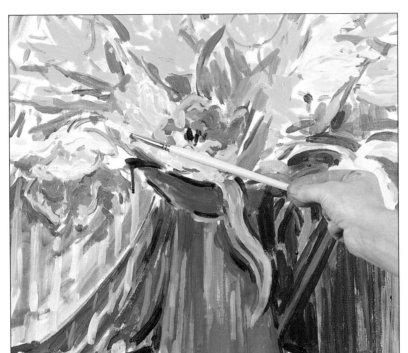

5

Paint the white stripes on the blue backcloth, adding a hint of brilliant blue to the white where the folds create shadows. Block in the dark cloth on the right with loose mixtures of raw umber, cadmium yellow deep and Hooker's green, scrubbing the paint on with vertical strokes of a fairly dry brush. Switch back to the medium-sized brush and paint the pale, creamy-coloured tulips with mixtures of azo medium yellow, titanium white and hints of cadmium scarlet. Use the paint thickly, undiluted, and apply it with prominent, textured brush strokes.

Right: This detail shows how the thick, juicy paint and swirling brush marks define the forms of the flowers and also lend rhythm and movement to the picture. The contrast of thick paint in the foreground, which appears to advance, and thinner paint in the background, which appears to recede, helps to create a sense of depth and three-dimensional space.

6

Finally, define the shadows on the tulip leaves with strokes of Hooker's green; this also emphasizes the graceful curves of the leaves. Refine the tones in the jug with further strokes of cobalt blue, brilliant blue and titanium white, blending the tones together with feathery strokes of the brush to model the jug's rounded form.

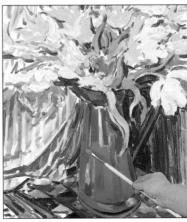

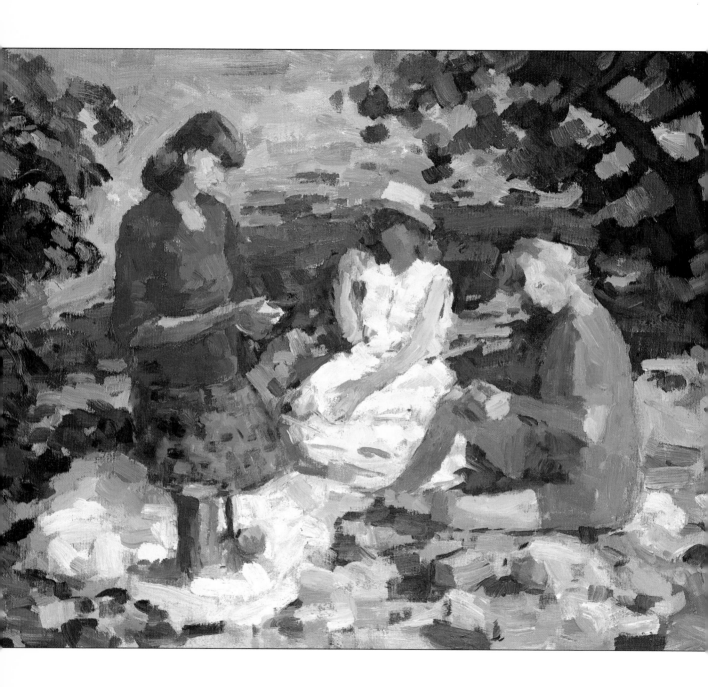

USING BROKEN COLOUR

In this painting the artist has adopted the Impressionist technique, using broken brush strokes of thickly applied paint in vibrant hues to create a shimmering web of colour. The paint, which is rich and buttery in consistency, has been applied in separate touches or strokes of a well-loaded bristle brush, building up wet layers over dry with some mixing of colour wet-into-wet on the surface of the painting. The lively dragged, broken and slurred brushwork gives a vital sense of light flickering off and blurring forms, evoking the atmosphere and light of summer.

Ted Gould
The Picnic
41 x 51 cm (16 x 20in)

BROKEN COLOUR TECHNIQUE

The term "broken colour" refers to a method of applying small strokes and dabs of different colours next to and over each other, so breaking up the paint surface into hundreds of tiny patches of colour, rather like a mosaic. When seen from the normal viewing distance these strokes appear to merge into one mass of colour, but the effect is different from that created by a solid area of smoothly blended colour. What happens is that the incomplete fusion of the strokes produces a flickering optical effect on the eye and the colours appear more luminous than a flat area of colour.

This technique is usually associated with the French Impressionist painters, who were the first to exploit its full potential. The Impressionists were fascinated by the fleeting, evanescent effects of outdoor light and found that using small, separate strokes of colour was an ideal way to capture the shimmering quality of the bright sunlight of southern France.

Acrylic paints are well suited to the broken colour technique because they dry rapidly, allowing you to superimpose layers of paint without muddying those beneath. Used straight from the tube, acrylics have a stiff, buttery consistency which is ideal for building up thick layers of impasto in which the mark of the bristle brush remains apparent in the raised paint. In general, short-haired flat bristle brushes (known as "brights") give the best results, as they hold a lot of paint and also offer a degree of control over the marks made.

When applying thick strokes of colour in this way, beware of overworking the texture, which would make the painting become clogged and heavy-looking. Apply each stroke decisively to the canvas and leave it alone. It is also a good idea to follow the Impressionists' example and allow the colour of the tinted canvas to show through in places. In the demonstration painting, for example, the artist began by tinting the canvas with a warm, golden colour; unpainted patches of this ground colour were left visible among the thick patches of paint, which not only add warmth but also breathe air into the painting.

Drybrush is another method of creating broken colour effects. A just-damp brush is lightly charged with colour, then skimmed across the dry canvas or paper. The brush leaves a small deposit of colour on the raised grain of the support, letting tiny specks of white sparkle through. The broken, ragged quality of drybrush strokes is very expressive.

THE PICNIC

Materials and Equipment

• SHEET OF CANVAS OR CANVAS BOARD • ACRYLIC COLOURS: CADMIUM YELLOW MEDIUM, SAP GREEN, ULTRAMARINE BLUE, PRISM VIOLET, TITANIUM WHITE AND CADMIUM RED MEDIUM • TUBE OF RETARDING MEDIUM • HOG'S HAIR BRUSHES: LARGE AND MEDIUM-SIZED FLATS, SMALL AND MEDIUM-SIZED FILBERTS • COTTON RAG

Above: This project painting was based on direct observation of the scene. The artist first made a tonal sketch in ballpoint pen to map out the major lights and darks, then a quick oil sketch to work out the main colour areas before embarking on the painting itself.

1

Start by staining the canvas with a warm tint mixed from cadmium yellow medium, sap green and a touch of ultramarine blue, diluted with water to a wash-like consistency. Apply the colour with a large flat brush, then rub it into the weave of the canvas with a cotton rag. Leave to dry. With a small filbert brush, broadly block in the main tones and outlines of the scene with a thin mixture of cadmium yellow medium, prism violet and ultramarine. Leave to dry.

2

Block in the lightest tones around the figures with thicker paint. (From this point on, add some retarding medium to your colour mixes to prolong the drying time of the paint and keep it workable.) Mix sap green, cadmium yellow medium and ultramarine blue in various proportions to create a range of warm, yellowish greens and cooler, bluish greens. With a medium-sized flat brush, apply short blocks of colour, varying the direction of the strokes to enliven the surface.

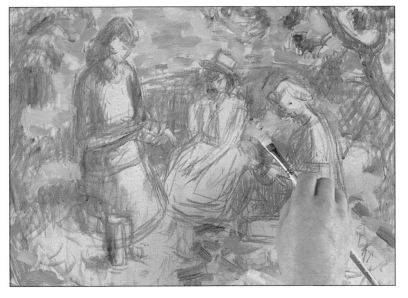

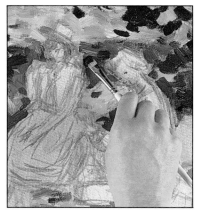

3

Block in the shadows in the grass and foliage using a medium-sized filbert brush and the same mixture, darkened with more ultramarine blue. Apply the paint thickly, using the body of the brush, and allow the brush marks to remain.

4

Rinse the brush and paint the whites of the picnic cloth and the central figure's dress. Use titanium white, modified with cool blues and violets in the shadows and spots of pink and yellow in the highlights. Again apply the colour using the flat of the brush, varying the direction of the strokes to follow the forms. Allow the colour of the stained canvas to break through the strokes and contribute to the feeling of sunlight.

Start blocking in the red areas with cadmium red medium, modified with hints of cadmium yellow medium and titanium white.

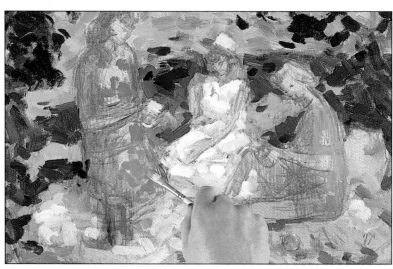

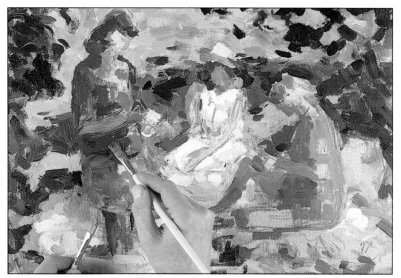

5

Continue working around the figure group, gradually building up a mosaic of thick, luscious colour. It is a good idea to work with two brushes, one carrying warm colours and one carrying cool colours, to avoid having to rinse out your brush too frequently. Paint the blue top of the left-hand figure and the blue vacuum flask with loose mixtures of ultramarine blue and titanium white, darkened with violet in the shadows.

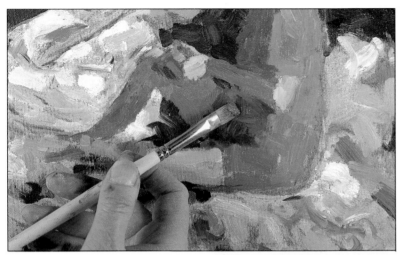

6

Paint the flesh tones of the figures with a small filbert brush and varying proportions of cadmium yellow medium, cadmium red medium and titanium white, adding hints of prism violet and sap green in the cool shadowy tones, such as the right-hand figure's face and her raised leg. Enrich the shadows on the red dress with hints of violet.

7

Use the medium-sized filbert brush and the same flesh tone mixture, lightened with more titanium white, to suggest patches of bare earth in the grass and break up the greens. Paint the hair of the right-hand figure with the same colour. For the dark hair of the remaining figures use rich browns mixed from cadmium red medium, cadmium yellow medium, prism violet and ultramarine blue. Suggest the pattern on the left-hand figure's skirt with strokes of violet and sap green.

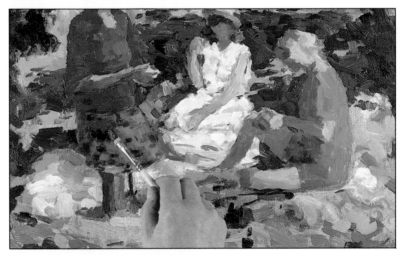

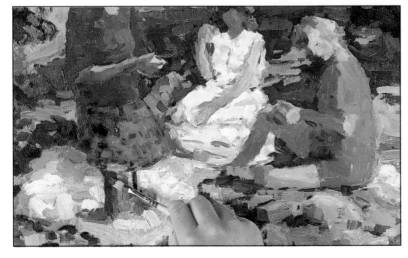

8

Continue working all over the canvas, modifying colours and tones as necessary and adding small touches of pure colour here and there to add luminosity to the picture. Suggest the features very sketchily – otherwise they will look too dominant.

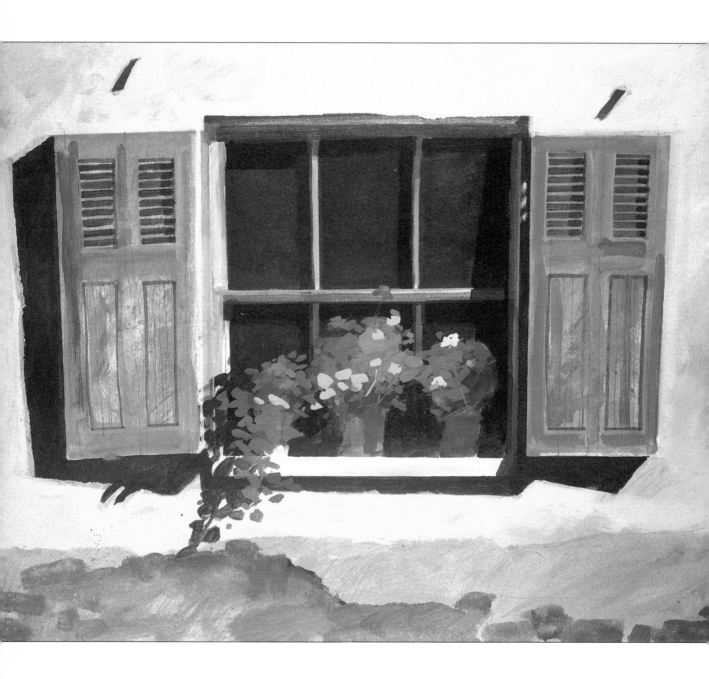

MASKING

Old buildings manage to retain their charm, even when in a slightly dilapidated condition, and to an artist with a creative eye they certainly make excellent subjects. This painting was based on a photograph of an old house in a French village. The artist was attracted by the contrast between the organic shapes of the potted geraniums, framed by the stark outlines of the shuttered window.

In the strong afternoon light the lines of the window and shutters, and the areas of light and shadow, were sharp and clearly defined. For these areas the artist adopted a masking technique using strips of masking tape and torn paper. This provided exactly the right degree of crispness to the outlines, which contrast effectively with the freer shapes of the plants.

Ian Sidaway
Window, La Garde Freinet
66 x 81cm (26 x 32in)

MASKING TECHNIQUES

Masking is a method of covering up specific areas of a painting with paper, cardboard or tape so that they remain untouched by paint being applied to adjacent areas. This has a liberating effect, allowing you to work more freely without the danger of spoiling an edge that needs to be straight and precise.

Masking tape is ideal where a crisp, hard-edged effect is required. This low-tack adhesive tape attaches firmly to paper, board or canvas, but can be peeled off easily without damaging the surface beneath. Make sure the support is perfectly dry before sticking the tape down firmly in the required position.

Mix the paint to a smooth, creamy consistency – if the paint is too thin, or the edge of the tape lifts, the colour will seep underneath the tape and the clean, sharp edge will be lost. Take the paint right over the edge of the tape to ensure a complete covering. Leave the painting to dry completely, then carefully peel away the tape to reveal a crisp, clean edge.

If you want an edge that is less straight and precise, use a torn piece of paper, or tear one edge of the masking tape. A torn mask produces a characteristic ragged edge, which would be difficult to achieve with a brush alone.

A variation on masking is stencilling, which involves cutting shapes out of strong paper, cardboard, acetate film or masking tape and dabbing paint through them. This enables you to repeat identical shapes over the picture surface.

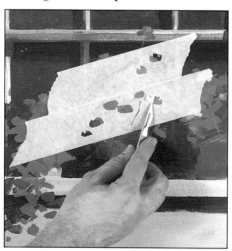

If you wish to paint a small shape with sharp, clean edges – such as highlighted foliage, as here, or a reflection in glass – apply masking tape to the area then cut out the shape with a sharp blade.

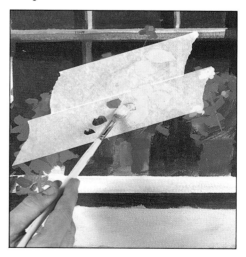

Apply paint to the cut-out areas, then leave the colour to dry completely before carefully peeling away the masking tape.

MASKING

WINDOW, LA GARDE FREINET

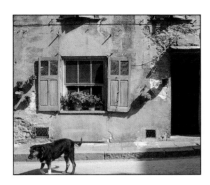

Left: The artist took this photograph while on holiday in France and decided to home in on the shuttered window as the subject of his painting.

Materials and Equipment

• SHEET OF CANVAS OR CANVAS BOARD • ACRYLIC COLOURS: CERULEAN BLUE, PAYNE'S GREY, YELLOW OCHRE, TITANIUM WHITE, MARS BLACK, RAW UMBER, RED OXIDE, PHTHALO GREEN, COBALT BLUE, CADMIUM RED AND CHROME YELLOW •HOG'S HAIR BRUSHES: LARGE AND MEDIUM-SIZED FLATS • SHEET OF SCRAP PAPER • MASKING TAPE • GRAPHITE OR SOFT PENCIL • MEDIUM-SIZED FLAT SOFT HAIR BRUSH

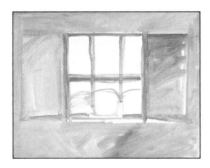

1

Using a large flat hog's hair brush, paint the window and shutters with a watery mix of cerulean blue darkened with a little Payne's grey. Add yellow ochre and titanium white to the mixture and paint the surrounding wall, again diluting the paint to a watery consistency. Scrub the paint on loosely.

2

Use a thin mix of mars black and raw umber to rough in the dark window panes and the shadows cast by the shutters and the windowsill.

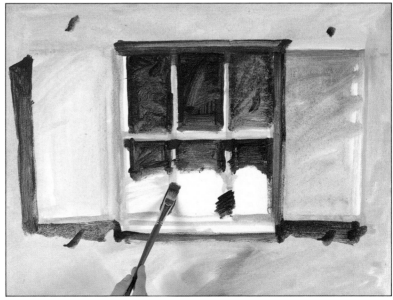

3

Block in the terracotta plant pots with a medium-sized flat hog's hair brush and mixtures of yellow ochre and red oxide. Then block in the base colour for the geranium leaves with phthalo green, yellow ochre and a little mars black, mixed in varying proportions to create light and dark tones. Leave to dry.

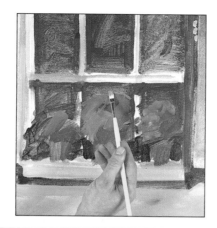

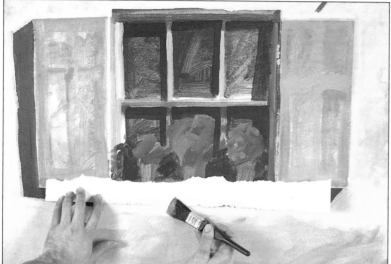

4

Having blocked in the main colours and tones you can now begin painting with slightly thicker, drier colour. Mix cerulean blue, titanium white and a touch of Payne's grey and strengthen the colour of the shutters using the large flat hog's hair brush. Work over the wall with varying proportions of yellow ochre, titanium white and a little Payne's grey. Use a large flat hog's hair brush, scuffing the paint on with loose, directional strokes to give texture to the wall. Tear a strip of paper and hold one edge against the edge of the shadow beneath the window and paint up against it.

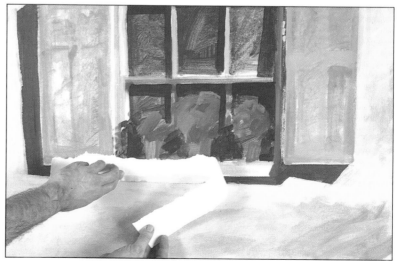

5

Peel the paper away to reveal a soft, slightly ragged line along the edge of the shadow. Repeat this process for the edges of the shadows cast by the shutters.

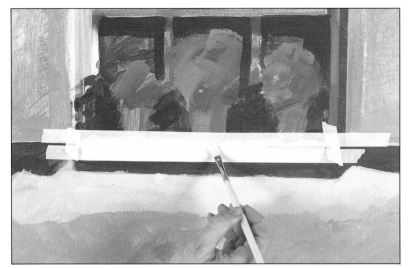

6

To create the highlight along the top of the windowsill, position two strips of masking tape with a small gap between them, as shown. Paint along the gap with the large flat brush and a pale mixture of titanium white and yellow ochre.

7

Leave the paint to dry, then peel away the strips of masking tape to reveal the crisp line of light.

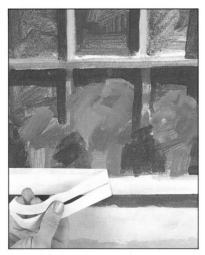

8

With the large flat hog's hair brush and a dark mix of Payne's grey and yellow ochre, strengthen the dark tone of the window panes. Leave to dry, then paint the shadows cast on the window panes with a second layer of colour. To obtain the crisp, yet irregular shapes of the shadows, lay one strip of masking tape with its edge butting up against the window frame. Lay another strip, with one torn edge, to the left of it, then paint in between the strips. Leave to dry, then remove the masking tape.

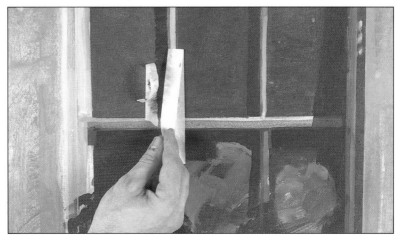

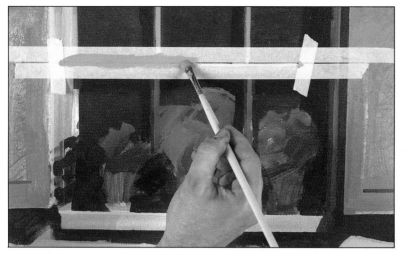

9

Paint the pale highlights on the upper window frames with the large flat hog's hair brush and a mixture of titanium white and a little cobalt blue. As in step 6, use strips of masking tape to achieve crisp, straight lines. When the paint is dry remove the strips of masking tape.

10

Using a medium-sized flat soft hair brush and a medium tone of Payne's grey, paint the linear details on the shutters. Masking tape isn't necessary here as the lines are not absolutely straight.

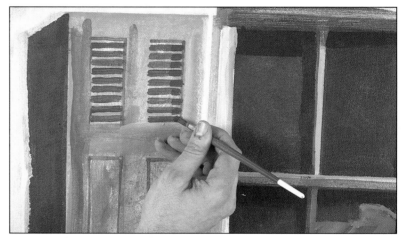

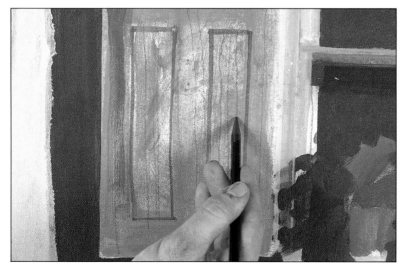

11

When the paint is dry, use a graphite pencil (or an ordinary pencil with a very soft lead) to draw a few lines on the shutters to suggest the texture of ageing wood.

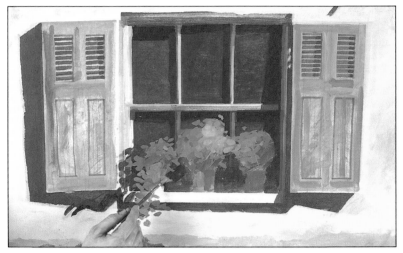

12

Paint the geranium leaves with the medium-sized flat soft hair brush and a basic mixture of phthalo green, yellow ochre and a little cadmium red. Vary the proportions of these colours to create a range of different greens, and add a little chrome yellow for the palest leaves. Leave to dry.

13

Darken the lower part of the wall with a watery wash of Payne's grey and yellow ochre, scrubbed on with loose strokes of the large flat hog's hair brush. Leave to dry, then go over the wall with a few loosely hatched pencil strokes to add textural interest.

Returning to the geraniums, paint the red flowers with neat cadmium red, adding a touch of cerulean blue for the salmon pink ones. For the pale pink flowers use white with a touch of cadmium red.

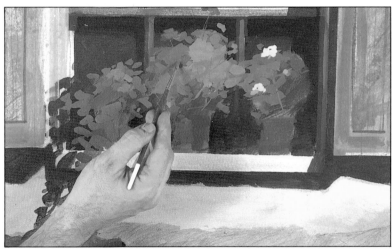

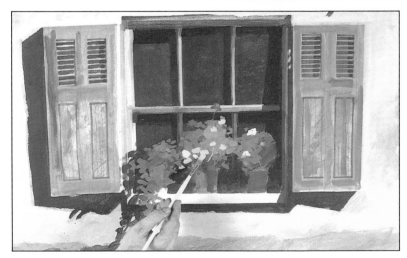

14

Finally, paint a few light-struck leaves with the medium-sized flat brush and a sharp green mixed from phthalo green, a little chrome yellow and white.

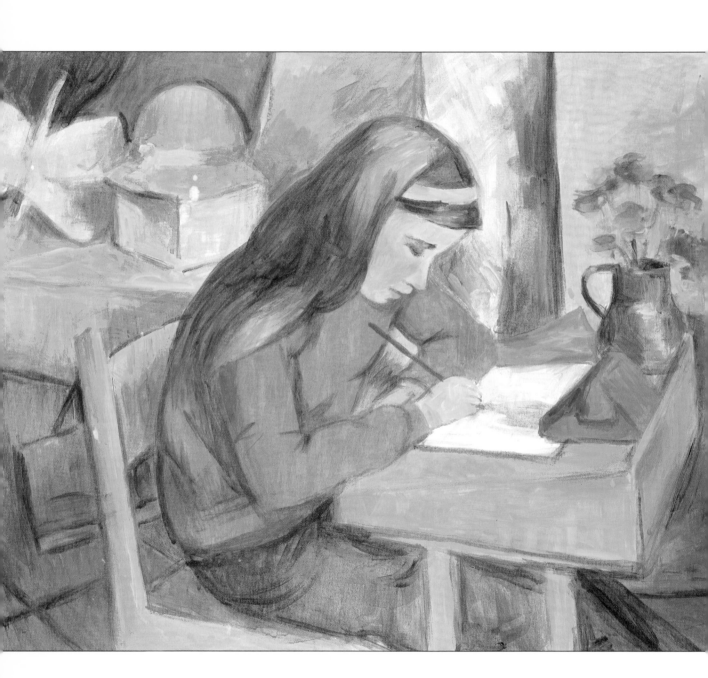

Technique

7

GLAZING

The Renaissance painters "mixed" their colours not by stirring them together on the palette, but by painting one transparent layer of colour over another, like sheets of coloured glass. Through using this method, know as glazing, they achieved the wonderful depth and luminosity of their colours. Glazing with oil paints, however, is a slow process; each layer must be thoroughly dry before the next one is applied – and oil paint takes a long time to dry. Acrylic paint, on the other hand, is perfectly suited to the glazing technique. Because it dries so quickly – and is waterproof when dry – you can paint one transparent layer over another in rapid succession.

This entire painting was built up with delicate glazes of colour applied over a thin underpainting. The artist diluted the paints with acrylic gloss medium. This increases the transparency of the paint while enriching the colour, and also makes the paint more "brushable". The brilliant white of the canvas further enhances the luminosity of the colours.

~

Ted Gould
Claire Studying
46 x 56cm (18 x 22in)

~

GLAZING TECHNIQUE

A glaze is a thin layer of transparent colour which is applied over another, dry, layer of paint. This produces two important effects. First, the transparency of the glaze allows light to pass through it and be reflected off the underlaying layer, which gives the paint a more luminous quality. Second, the glaze combines optically with the paint below to produce a new colour. For example, a transparent glaze of blue over yellow produces a green, while a glaze of red over yellow produces a warm orange. Colours mixed in this way are quite different in character from colours mixed together on the palette. Glazed colours seem to transmit light from within, whereas with opaque colour the light is on the surface only. In short, glazing modifies the underlying colour and makes it more luminous.

Paint for glazing can be diluted with water and/or acrylic medium. Some manufacturers make a special acrylic glaze medium, which will give a more transparent, even glaze than either of the other two. When diluted with water alone, the glaze dries to a dull, matt finish, which some artists prefer. However, the colours can be enlivened by applying a coat of acrylic varnish or medium to the finished painting.

To make a glaze, mix the paint with water or medium on the palette with a wet brush or palette knife. The paint should have a creamy, fluid consistency. Apply the glaze with either a bristle or soft hair brush and work it into the canvas to form a smooth, even layer. It is best to lay your canvas flat on a table or on the floor, as this prevents the paint from running.

Always begin with the lightest colours and work up to the darkest, so that light is able to reflect up through the colours from the white canvas or paper and makes them more luminous. Never add white to lighten the tone of a glaze; it will turn the colour milky and opaque. It is essential to allow one glaze to dry completely before applying the next, otherwise the clarity of the glaze is lost as the two colours partially mix and become muddy. With acrylics, of course, the colours are dry within minutes.

Here a thin wash of cadmium red is applied over a dry layer of cadmium yellow. The two colours blend in the viewer's eye to produce a subtle orange colour. Always apply the lightest colour first, so that light can reflect off the white canvas or paper and enhance the translucency of the colours.

CLAIRE STUDYING

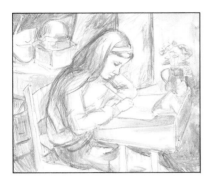

1

Mix quinacridone violet, burnt sienna and a little cobalt blue and dilute to a thin consistency with water. Using a small filbert brush make a loose underdrawing of the composition with this colour, roughly blocking in the dark tones. Allow to dry.

Materials and Equipment

• SHEET OF SMOOTH CANVAS, CANVAS BOARD OR PRIMED HARDBOARD (MASONITE) • ACRYLIC COLOURS: QUINACRIDONE VIOLET, BURNT SIENNA, COBALT BLUE, CADMIUM YELLOW, NAPHTHOL CRIMSON, YELLOW OCHRE, MARS BLACK AND TITANIUM WHITE • HOG'S HAIR BRUSHES: SMALL FILBERT; LARGE AND SMALL FLATS • TUBE OF ACRYLIC GLOSS MEDIUM

2

From this point onwards, mix acrylic gloss medium into your colours to increase the transparency of the paint. Dilute further with water if necessary. Mix a thin wash of cadmium yellow with a little burnt sienna added. Apply this over most of the canvas, as shown, with a large flat brush. This sets a warm colour key for the succeeding colours. Allow a few minutes for the paint to dry.

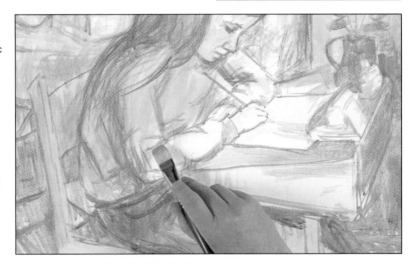

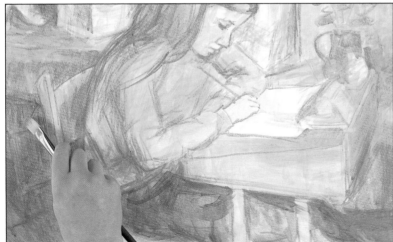

3

Mix quinacridone violet and cobalt blue in the same way and apply this as a base for those areas which are to be violet or blue in the finished painting, such as the girl's trousers, the floor and parts of the background.

Left: This detail shows how the colours are kept very thin and transparent, allowing the white of the canvas to glow up through them. So that the forms do not dry with a hard edge, quickly blot the brush on a rag and feather over the edges lightly to soften them.

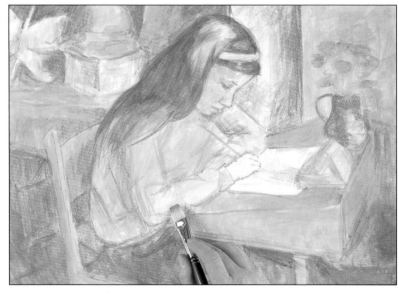

4

Mix a wash of burnt sienna with a little quinacridone violet and cobalt blue added. Apply this over the girl's hair, leaving the golden highlights and the hair band untouched. Strengthen the warm yellow tones with further glazes of cadmium yellow.

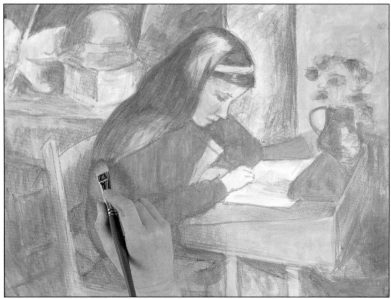

5

Paint the girl's sweater and the telephone with a thin glaze of naphthol crimson with a touch of yellow ochre added. Then work around the painting, adding touches of this warm colour to the background, the flowers in the vase and the girl's hair.

6

Using a small flat brush, define the sleeves and the creases in the sweater with loose drybrushed strokes of very weak mars black. Work up the shadows on the sweater using a large flat brush and thin glazes of violet.

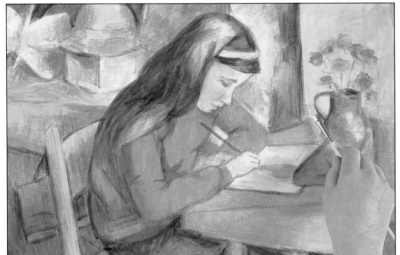

7

Use a small filbert brush to suggest the texture of the girl's hair with light strokes of thin, dry mars black paint, except in the highlights. Use the same colour for the pencil in her hand and to emphasize some of the outlines.

Continue to work all over the canvas adding further glazes of colour to strengthen the image. Add touches of thin titanium white paint in the background and paint the open book with white, adding violet for the cast shadows. Keep the paint wet and thin.

8

Darken the hair with a final glaze of naphthol crimson. Paint the face and hands using a small flat brush and a base mixture of titanium white and naphthol crimson for the light areas. Add more naphthol crimson and some yellow ochre in the cheek and blend the colours together lightly to emphasize the softness of the features. Paint the lips with some of the cheek colour and the eye with mars black and burnt sienna, keeping the colours soft and light. Paint the hair band yellow.

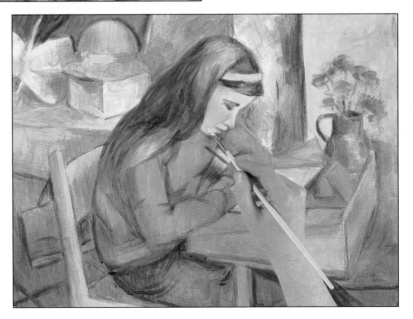

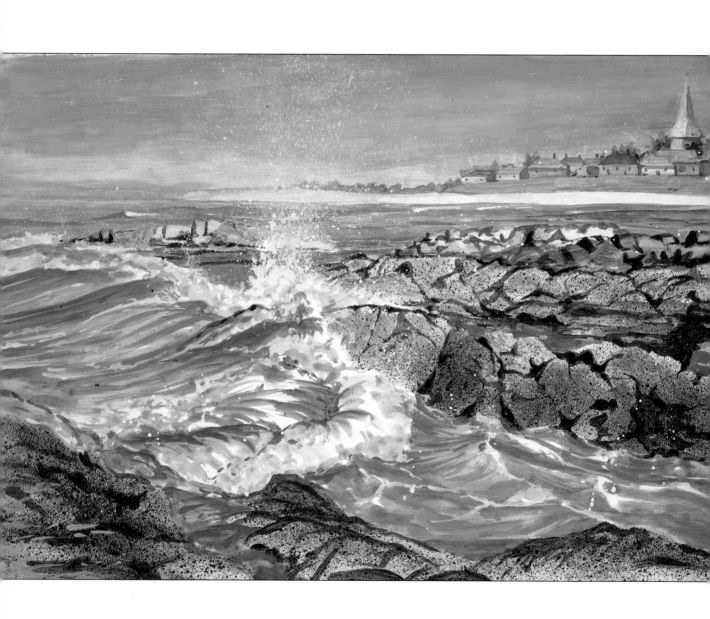

Technique

8

SPATTERING

This painting contains many interesting contrasts of form and texture. In the foreground the jagged rocks, swirling waves and crashing surf combine to create dramatic tension, while the distant coastline appears tranquil and serene.

To emphasize the rugged texture of the rocks, and to suggest the force of the breaking waves, the artist has used a technique called spattering. A paint-filled brush was held above the painting and tapped sharply, making the paint fall in a mass of tiny, irregular spots. Often used in watercolour painting, spattering is an excellent means of suggesting certain textures and effects without overstating them.

~

Mark Topham
Seascape
36 x 51cm (14 x 20in)

~

SPATTERING TECHNIQUES

Generally, spattering is used only on small areas of a painting because too much of it can appear mechanical and "tricksy". But when used with discretion it is an excellent technique for simulating rough, pitted textures such as sand, rocks and stones, or for capturing the movement of crashing surf.

When spattering, lay the painting flat on a table or on the floor, otherwise the spattered paint may run down the surface. Use tracing paper to mask off those parts of the painting that are not to be spattered. This allows you to work freely within a specific area. The paint should be wet, but not too runny – the consistency of medium-thick cream.

There are two different methods of spattering. One is to dip an old toothbrush into fairly thick paint and, holding it horizontally a few inches above the painting surface, quickly draw a thumbnail through the bristles. This

action releases a shower of fine droplets onto the painting below.

The second method is to load either a stiff bristle brush or a watercolour brush with long bristles, then tap the brush sharply across a finger or across the handle of another brush. This produces a slightly denser spatter with larger droplets. For a slightly finer spatter, gently tap the brush with an extended forefinger.

Spattering is a random and fairly unpredictable technique and it is advisable to experiment on scrap paper to discover the effects it can create before trying it out on a painting. For example, vary the distance between the brush and the painting surface to increase or decrease the density of the dots. Or try spattering onto a damp surface so that the dots become softened and diffused. Finally, spatter with two or more tones or colours.

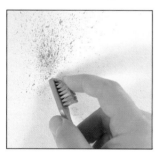

To produce a fine spatter, use a toothbrush and fairly thick paint. Dip the toothbrush into the paint, hold it at an angle to the paper, then draw your thumbnail through the bristles.

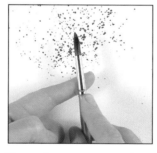

To produce a more random spatter, load a round brush with paint and tap it sharply with your outstretched forefinger.

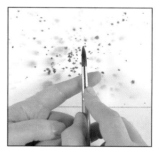

Spattering onto a damp surface produces a soft, blurred effect. Try spattering with two or more colours to create subtle tones and hues.

SEASCAPE

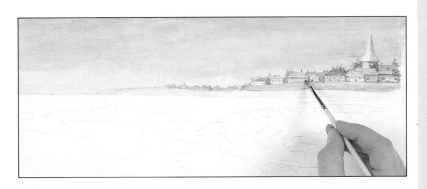

Materials and Equipment

• SHEET OF SMOOTH CANVAS, CANVAS BOARD OR PRIMED ILLUSTRATION BOARD • HB PENCIL • TUBE OF RETARDING MEDIUM • ACRYLIC COLOURS: TITANIUM WHITE, CERULEAN BLUE, COBALT BLUE, UNBLEACHED TITANIUM WHITE, ULTRAMARINE BLUE, PHTHALO GREEN, RED IRON OXIDE, YELLOW OCHRE, DIOXAZINE PURPLE, PAYNE'S GREY, BURNT UMBER, ALIZARIN CRIMSON, RAW SIENNA AND BURNT SIENNA • BRISTLE BRUSHES: SMALL AND MEDIUM-SIZED FLATS, SMALL ROUND • SOFT HAIR BRUSHES: SMALL AND MEDIUM-SIZED ROUNDS • SHEET OF TRACING PAPER SAME SIZE AS PAINTING • CRAFT KNIFE • OLD WATERCOLOUR BRUSH FOR APPLYING MASKING FLUID • MASKING FLUID (LIQUID FRISKET) • OLD TOOTHBRUSH • SHEET OF SCRAP PAPER OR NEWSPAPER

1

Sketch in the main outlines of the composition in pencil. Squeeze out some retarding medium along with your palette of colours; a little should be added to each of your colour mixtures to prolong the drying time of the paint and facilitate smooth brush strokes. With a medium-sized flat bristle brush, mix a pale blue from titanium white with a little cerulean blue and cobalt blue, and dilute quite thinly with a little water. Block in the sky, making it paler towards the horizon so as to give an impression of receding space.

Use a small flat bristle brush to paint the details on the far shore, keeping all the tones pale and hazy.

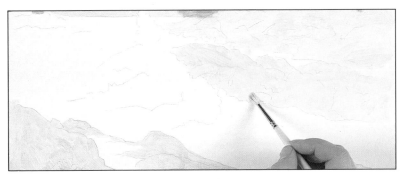

2

Still using thinly diluted colour, paint the narrow area of sea in the background with titanium white, ultramarine blue, dioxazine purple and Payne's grey, loosely mixed. Mix burnt umber and ultramarine blue for the dark rocks jutting into the sea. For the remaining rocks use unbleached titanium white with traces of red iron oxide and ultramarine blue, making the tones increasingly stronger as you work towards the foreground.

3

Paint the dark fissures in the rocks with a dark tone of ultramarine blue and alizarin crimson. Leave to dry, then mix thin glazes of raw sienna, burnt umber and ultramarine blue in varying combinations. Wash these over the rocks to build up their forms, using a medium-sized flat bristle brush. Paint the pools of water with various blues mixed from cobalt blue and raw sienna, and ultramarine blue and dioxazine purple.

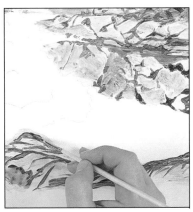

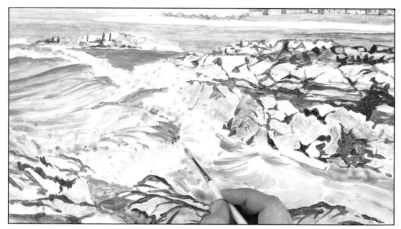

4

Mix ultramarine blue and phthalo green to create a cool turquoise. Paint the incoming waves with a small round bristle brush and thin paint, this time with no retarder added. Working around the areas of pure white surf, define the waves with strokes of Payne's grey and dioxazine purple for the dark areas, cerulean for the light areas, and a sea green mixed from phthalo green and ultramarine blue. Use sweeping strokes that follow the smooth, undulating forms of the waves.

5

Strengthen and refine the colours in the water using the same colours as in step 4, this time using slightly thicker paint with retarder added. Paint the brightest highlights on the crashing surf with titanium white, adding hints of blue to model their three-dimensional forms. Suggest the waves in the distance with small strokes of dioxazine purple and Payne's grey for the dark underwaves, and titanium white for the tops of the waves. Leave the painting to dry.

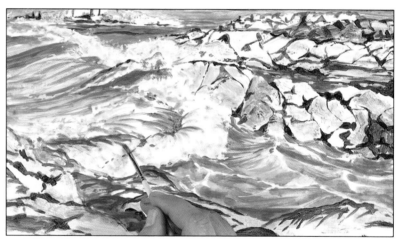

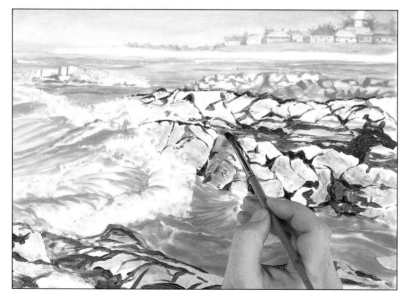

6

In preparation for spattering the rocks and the sea spray, you will need to make a mask to protect the rest of the painting. Lay a sheet of tracing paper over the painting and trace around the outlines of the rocks in the foreground and middle ground, but not those in the distance. Remove the tracing paper and cut out the shapes of the rocks with a craft knife, then re-position the tracing paper over the painting. Using an old paintbrush, apply masking fluid (liquid frisket) over the small, fiddly shapes of the rock pools so that they too are protected from the spattered paint.

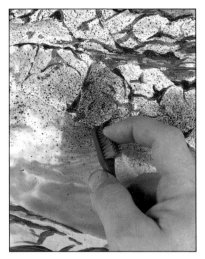

7

Now you are ready to use the spattering technique to add texture to the rocks. Dilute burnt sienna with enough water (but no retarder) to give it a thick, creamy consistency. Dip an old toothbrush into the paint and hold it as shown, about 2 to 3 cm (1in) above the rocks in the middle ground. Run a fingernail through the bristles to release a fine spray of paint onto the rocks.

Work over the whole area in this way, making the spray denser in some areas to create variations in tone from light to dark. Then repeat the process using Payne's grey.

8

Spatter the foreground rocks with burnt umber. When dry, remove the tracing paper and rub away the masking fluid with a fingertip.

Wash the toothbrush thoroughly and then load it with titanium white and begin spattering the sea spray in the middle of the picture. Place a sheet of paper beneath the area to be spattered. Position the brush close to the surface and at the base of the area to be spattered, as you want the paint to shoot upwards to mimic the action of the sea spray. Run a fingernail through the bristles as before, but this time in a more controlled way so as to create larger and denser droplets.

9

Mix titanium white to a creamy consistency and apply some dense, heavy spattering at the base of the sea spray, at the point where the wave crashes against the rocks. This time use a medium-sized round soft hair brush, well loaded with paint. Hold it about 5cm (2in) from the surface and tap it sharply against your extended finger to release a shower of large, heavy droplets in contrast to the fine spray created with the toothbrush.

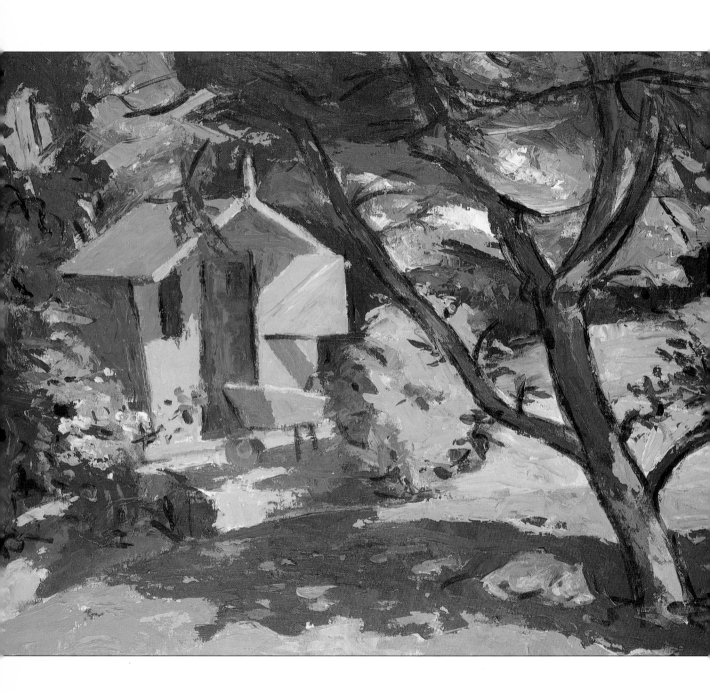

PAINTING WITH A KNIFE

The richly textured surface of this painting has been achieved by applying the paint with a knife. The artist began with an underpainting in thin colour to establish the major tones and colours. Then the image was developed with thick, juicy paint, "sculpting" the textures and forms with the flexible blade of the knife.

No sky is visible in the painting, but the viewer is in no doubt that it was painted on a sunny day. The cool blues and violets of the shadows contrast strikingly with the patches of warm, pinkish brown woven throughout the composition, creating an impression of strong sunlight.

~

Ted Gould
Summer Garden
46 x 56cm (18 x 22in)

~

USING A PAINTING KNIFE

A painting knife is an excellent tool for applying thick acrylic paint in a bold and spontaneous manner. Painting knives should not be confused with palette knives, which have long blades and are used for mixing paint on the palette and for cleaning up. Painting knives have shorter, broad blades and rounded tips, and most have a cranked handle to raise the hand away from the wet canvas.

Gel medium, a thickening agent, can be mixed into the paint on the palette before it is applied to the canvas. The added thickness means that greater texture can be created in the paint with the blade of the knife. The gel looks milky when it comes out of the tube, but becomes transparent as it is mixed with the paint.

Pick up a generous amount of paint on the underside of the knife. Use the full width of the blade to make bold, broad strokes and the tip for smaller, detailed ones. Don't move the knife back and forth; set it down firmly on the canvas and spread the paint with a single, decisive movement, lifting the blade cleanly away when the stroke is completed.

A painting knife is a versatile instrument, and by using different parts of the blade you can achieve quite different strokes and effects. Try holding the knife at various angles and changing the pressure you apply. For example, painting with the flat base of the blade, spreading the paint very thickly, produces a smooth surface that reflects the maximum amount of light. Holding the knife at a slight angle to the canvas and applying firm pressure gives a thinner covering which allows the texture of the canvas to show through the paint. Using a brisk patting motion with the tip of the blade creates a rough, stippled texture. Using the tip of the blade to scratch through a layer of wet paint will reveal the colour beneath.

Always clean your painting knife thoroughly before laying it down for any length of time, and especially at the end of a painting session, otherwise the paint will dry hard on the blade and be difficult to remove.

Attractive effects can be achieved by partially blending two colours wet-into-wet. Apply one colour over another, then use the heel of the knife to spread the paint in different directions.

SUMMER GARDEN —————

Materials and Equipment

• SHEET OF CANVAS OR CANVAS BOARD • ACRYLIC COLOURS: COBALT BLUE, SAP GREEN, SPECTRUM VIOLET, CADMIUM YELLOW PALE, CADMIUM RED MEDIUM, TITANIUM WHITE AND MARS BLACK • BRISTLE BRUSHES: MEDIUM-SIZED ROUND; LARGE AND SMALL FLATS • TUBE OF GEL MEDIUM • TROWEL-SHAPED PAINTING KNIFE

1

Plot the main elements of the composition using very dilute sap green and a medium-sized round bristle brush.

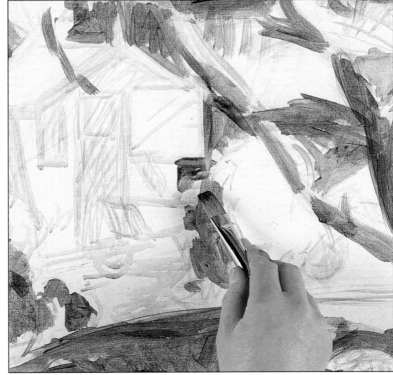

2

Mix cobalt blue and sap green to make a dark green and dilute to a watery consistency. Using a large flat brush, broadly block in the cool shadow areas and the darkest tones in the grass and foliage.

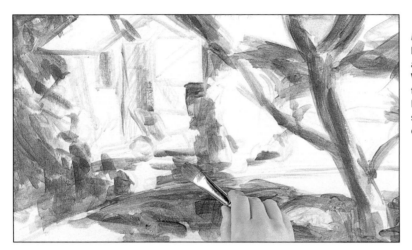

3

Mix violet and a little cobalt blue, again diluted to a thin consistency. With the large flat brush, lightly touch in the warmer shadows which have a violet tinge, for example the shadows cast on the path and in the doorway of the garden shed.

4

Block in the sunlit areas of grass and foliage with a dilute mixture of cadmium yellow pale and sap green. Mix cadmium red medium, cadmium yellow pale and a touch of violet as a base for the warm colour of the cedarwood shed, the path and the ginger cat lying under the tree.

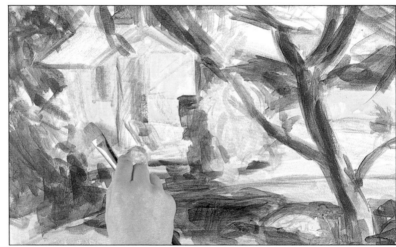

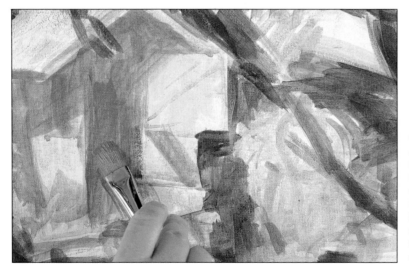

5

Add more violet to the mixture used to paint the shed in step 4 and paint the shadows cast onto the walls and doorway of the shed. This underpainting of thin colour helps to kill the glaring white of the canvas and establishes the overall colour scheme of the painting, ready for the application of thicker paint.

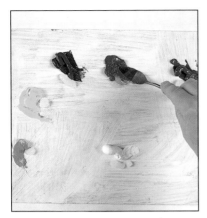

6

Now that the underpainting is complete, clean your palette and squeeze some fresh paint onto it – you will need cadmium red medium, cadmium yellow pale, sap green, cobalt blue, violet and titanium white. Squeeze out a small amount of gel medium next to each colour and mix it into the paint using the painting knife (clean the knife between colours). The gel medium thickens the paint so that it produces thick, textural wedges.

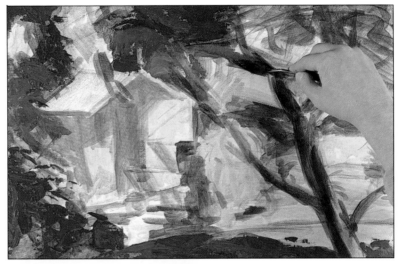

7

Mix sap green and cobalt blue to make a dark green. Pick up plenty of paint on your knife, undiluted with water, and apply it with thick dabs and strokes over the dark shadow areas underpainted in step 2. Don't attempt any detail at this stage – just block in the main masses. Vary the direction of the knife to give a lively movement to the picture surface.

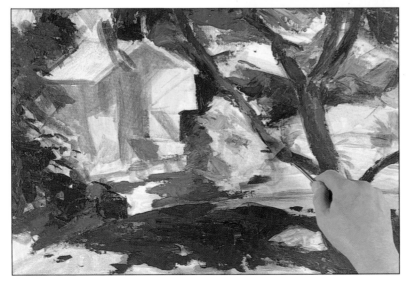

8

Now go over the violet shadows underpainted in step 3 with a mixture of violet and cobalt blue. "Slur" the paint on with the edge of the knife, letting the knife marks show. For the shadows on the tree branches, apply the paint with the tip of the knife and drag it downwards.

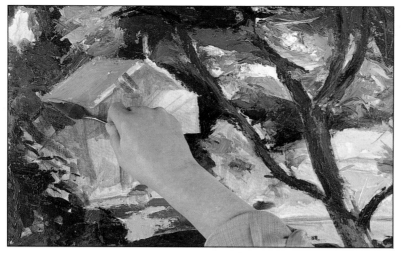

9

Paint the foliage in the background with pale greens mixed from various proportions of cobalt blue, sap green and titanium white, varied and enriched with cadmium yellow pale in places. Keep the colours broken and the knife marks varied to give a sense of movement to the foliage.

Mix cobalt blue, white and a touch of violet to create a metallic grey. Use this to paint the roof of the shed and the light side of the wheelbarrow. Use the edge of the knife to smooth the paint on.

10

Paint the bush to the left of the shed with pale greens mixed from titanium white, cadmium yellow pale and sap green, using the tip of the knife to apply the paint in small dabs. Paint the shadow side of the shed with a warm brown mixed from cadmium red medium, cadmium yellow pale, spectrum violet and a touch of cobalt blue. Use the edge of the knife blade to scratch one or two lines into the paint to give textural interest to this flat area of colour.

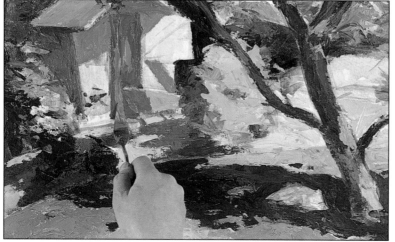

11

Paint the warm, light foliage greens in the foreground with varied mixtures of sap green, cadmium yellow pale and titanium white. Paint the shadows cast on the front of the shed with the same brown used in step 10, lightened with more cadmium yellow pale and a little titanium white. For the dark tone of the doorway add more spectrum violet and cobalt blue to the mixture.

To indicate sunlight reflected into the doorway, add a few vertical strokes of pure cadmium red medium, blending them into the brown but not completely.

12

Mix cadmium red medium,
cadmium yellow pale, titanium white
and a hint of spectrum violet and
complete the front of the shed. With
the same colour, go around the
painting adding patches of warm
sunlight on the path, in the grass
and on the tree trunk and branches.
Paint the cat with various tones of
this same colour.

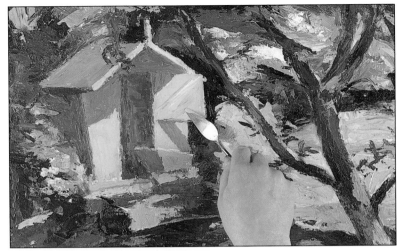

13

Paint the wheel of the wheelbarrow
with a dark grey, with cadmium red
medium in the centre. Mix cobalt
blue, sap green and a touch of
spectrum violet to make a dark
greenish black, and paint the
windows in the shed.

14

Finally, use a small flat brush to
outline the tree trunk and branches
with broken strokes of mars black to
give them emphasis.

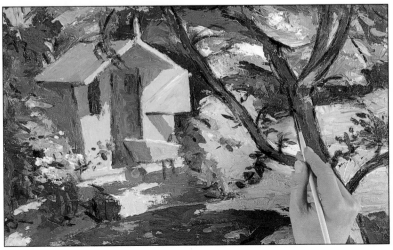

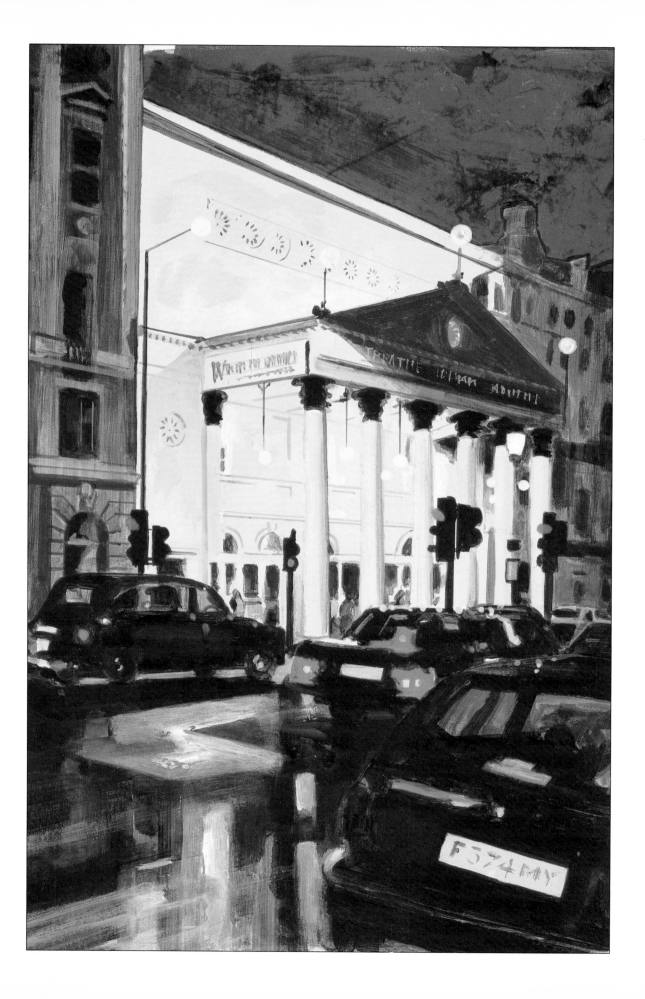

Technique

10

USING FLUORESCENT COLOURS

This is a highly atmospheric image evoking all the excitement and colour of the city at night. The artist has used bright fluorescent colours to capture the characteristic twinkle of neon traffic signals and the glare of a floodlit building contrasted against the surrounding gloom. The scene was painted on a showery evening, and the blaze of artificial lights softly reflected in the wet road adds even more colour and excitement.

~

Phil Wildman
City Lights
46 x 33cm (18 x 13in)

~

FLUORESCENT COLOURS

Due to their versatility, acrylic paints lend themselves exceptionally well to mixed media work. They can be used in combination with other water-based media, such as watercolour, gouache and ink, and with drawing materials, including pencil, charcoal, pastel and crayon.

In this project acrylic paints are combined with gouache for a specific reason: gouache paints include a range of bright fluorescent colours, which are not available in acrylic, and this particular image relies for its effect on small spots of brilliant colour contrasting with the surrounding dark areas. The only problem with gouache paints is that the colours remain soluble even when dry, so that brushing a layer of wet paint over another one below tends to muddy the colours. Gouache paints also dry with a flat, matt finish which may differ noticeably from the finish of the acrylic paints.

However, gouache paints can be mixed with acrylic medium (matt or gloss), effectively turning it into acrylic paint. The medium renders the gouache colours waterproof when dry, allowing successive washes to be overlaid without disturbing the underlying colours. When mixed with medium the fluorescent gouache colours lose none of their strength and brilliance, even when diluted to a thin, watery consistency.

Brush ruling

In this project the artist has used a technique called brush ruling to paint the fine linear details on the buildings. Painting straight lines with a brush can be tricky because the brush tends to wobble and it is difficult to control the flow of paint. To draw a fine line with a brush, hold a ruler firmly above the support, bunching your fingers underneath it so that its edge is not touching the surface of the support. Place the ferrule of the brush against the edge of the ruler and draw the brush gently along. Because the ruler does not touch the support, there is no risk of smudging the line when the ruler is removed.

Squeeze some fluorescent gouache paint and some acrylic gloss medium onto your palette, then mix them together thoroughly using a palette knife.

CITY LIGHTS

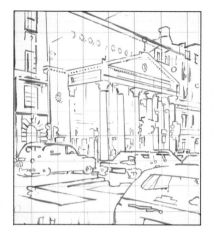

1

With a fairly detailed image such as this one, it is advisable to use the squaring-up method (see page 19) to transfer the main outlines of the composition from the reference photograph to your support. Here the artist has drawn the outlines with a brush and thin paint, but you could use pencil if you prefer.



Materials and Equipment

• SHEET OF CANVAS OR CANVAS BOARD • PENCIL • RULER • ACRYLIC COLOURS: ULTRAMARINE BLUE, DEEP VIOLET, TITANIUM WHITE, YELLOW OCHRE, BURNT UMBER, PAYNE'S GREY, BURNT SIENNA, CADMIUM RED AND LEMON YELLOW • GOUACHE COLOURS: FLUORESCENT YELLOW, RED AND GREEN • ACRYLIC GLOSS MEDIUM • HOG'S HAIR BRUSHES: LARGE AND MEDIUM-SIZED FLATS • PAINTING KNIFE • RETARDING MEDIUM • SOFT HAIR BRUSHES: SMALL ROUND; LARGE FLAT



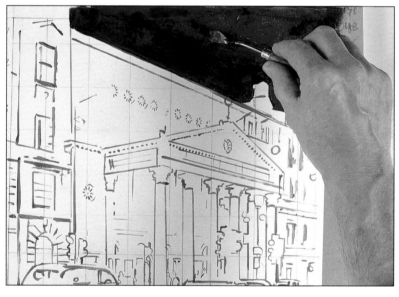

2

Mix a deep, rich blue from ultramarine blue and a touch of deep violet. Dilute to a thick, creamy consistency with a little acrylic gloss medium and fill in the sky area using a large flat hog's hair brush. Apply a further thick layer of colour with a painting knife; use the knife like a trowel, scraping the paint away in places to create light areas and building it up elsewhere to create darker tones, to give the effect of the cloudy night sky.

3

Squeeze some fluorescent yellow gouache paint onto your palette and use your painting knife to mix some gloss medium into it.

Mix titanium white with the fluorescent yellow mixture and a touch of yellow ochre to make a pale but brilliant yellow. Dilute quite thinly with acrylic gloss medium and a little water and paint the front of the theatre building with a large flat soft hair brush.

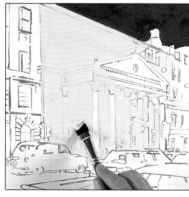

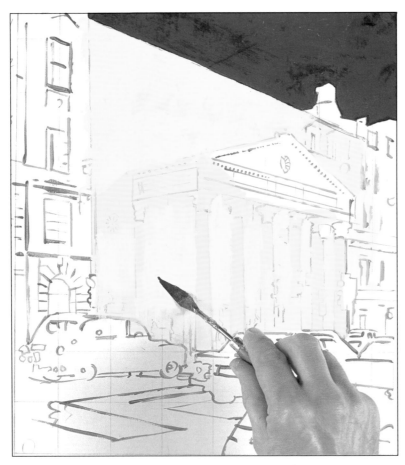

4

Add more titanium white to the mixture to thicken it and to lighten the tone. Go over the area just painted once more, leaving the columns at the front of the theatre untouched. Use a combination of a medium-sized flat hog's hair brush and a painting knife to give texture to the paint surface.

5

Create a semi-blended mixture of burnt umber, ultramarine blue and a touch of yellow ochre on your palette. Mix a little retarding medium into the paint to slow down the drying rate and dilute thinly with water. Paint the dark buildings on either side of the theatre, scrubbing the paint on quite thinly. Gradually lighten the tone near the base of the walls, which are lit by the street lights.

Use various tones of the same mixture for the road, applying the paint thinly with vertical streaks. Mix ultramarine blue and burnt umber for the darker tone of the windows and for the pediment and column tops at the entrance to the theatre.

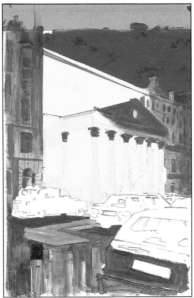

6

Paint the cars with a medium-sized flat hog's hair brush and Payne's grey varied with touches of ultramarine blue and burnt umber. Start with light washes and build up to the darkest tones with further layers of colour.

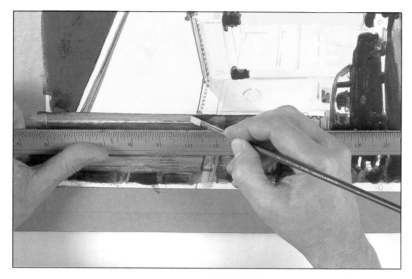

7

To suggest reflected light on the protruding walls of the left-hand building, apply a thin, dry layer of titanium white with a medium-sized flat hog's hair brush, using the brush ruling method described on page 90.

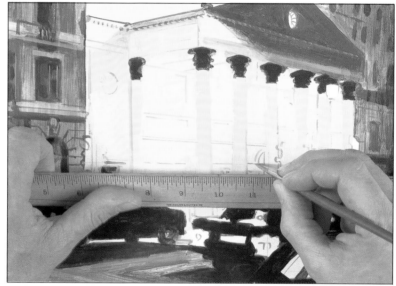

8

Paint the linear details on the theatre building with a small round soft hair brush and a mixture of titanium white and burnt sienna, again using the brush ruling technique.

9

Using a small round soft hair brush, paint the doors and windows at the theatre entrance with burnt sienna overlaid with burnt umber and Payne's grey to vary the tones. Paint the shadows on the columns with a pale wash of Payne's grey and yellow ochre. Suggest the dark figures in the street with various tones of Payne's grey, burnt umber and titanium white applied with loose strokes.

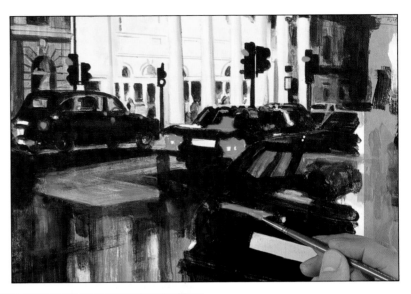

10

Paint the traffic signals with a medium flat hog's hair brush and a dark mix of Payne's grey and burnt umber. Leave to dry. Mix fluorescent red gouache paint with acrylic gloss medium, then deepen the colour with some cadmium red acrylic paint. Use a small round soft hair brush to paint the glowing red lights and their reflections. Dilute the colour to a pale tint and paint the red reflections in the road with vertical strokes of a medium flat hog's hair brush.

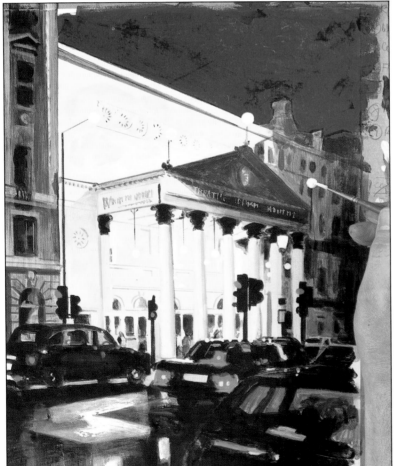

11

Mix fluorescent yellow gouache with gloss medium and add a little lemon yellow acrylic paint. Use this to paint the yellow lights and their reflections as in step 10. Paint the single green traffic signal with fluorescent green gouache mixed with gloss medium. Paint the white reflections in the road with thin, dry titanium white paint. Finally, paint the white lamps above the portico.

SUPPLIERS

SUPPLIERS

Winsor & Newton
painting and drawing materials
51 Rathbone Place
London W1P 1AB
Tel: 071–636 4231

George Rowney & Co Ltd
painting and drawing materials
12 Percy Street
London W1A 9BP
Tel: 071–636 8241

Russell & Chapple Ltd
general art supplies
23 Monmouth Street
London WC2H 9DD
Tel: 071–836 7521

L Cornelissen & Son Ltd
general art supplies
105 Great Russell Street
London WC1B 3LA
Tel: 071–636 1045

John Mathieson & Co
general art supplies
48 Frederick Street
Edinburgh EH2 1HG
Tel: 031 225 6798

Copystat Cardiff Ltd
general art supplies
44 Charles Street
Cardiff CF1 4EE
Tel: 0222 344422
Tel: 0222 566136 (mail order)

The Two Rivers Paper Company
hand-crafted papers
Pitt Mill
Roadwater

Watchet
Somerset TA23 0QS
Tel: 0984 41028

Frank Herring & Sons
easels, sketching stools, palettes
27 High West Street
Dorchester
Dorset DT1 1UP
Tel: 0305 264449

Art Supply Warehouse
general art supplies (mail order)
360 Main Avenue
Norwalk
CT 06851
USA
Tel: (800) 243–5038

**Artisan/Santa Fe Art
Supplies, Inc**
general art supplies (mail order)
Canyon Road
Santa Fe
NM 87501
USA

Creative Materials Catalog
general art supplies (mail order)
PO Box 1267
Gatesburg
IL 61401
USA
Tel: (800) 447–8192

Hofcraft
general art supplies (mail order)
PO Box 1791
Grand Rapids
MI 49501
USA
Tel: (800) 435–7554

Pearl Paints
general art supplies (mail order)
308 Canal Street
New York
NY 10013–2572
USA
Tel: (800) 451–7327

MANUFACTURERS

Winsor & Newton
painting and drawing materials
Whitefriars Avenue
Wealdstone
Harrow
Middx HA3 5RH
Tel: 081–427 4343

Daler-Rowney Ltd
painting and drawing materials
PO Box 10
Southern Industrial Estate
Bracknell
Berks RG12 8ST
Tel: 0344 42621

Pro Arte
specialist brushes for acrylics
West Lane
Sutton in Craven
Nr Keighley
W Yorks BD20 7AX
Tel: 0535 632143

Binney & Smith (Liquitex UK)
acrylic products
Ampthill Road
Bedford MK42 9RS
Tel: 0234 360201

INDEX

PICTURE CREDITS
The author and publishers would like to thank the following for permission to reproduce additional photographs:

The Bridgeman Art Library: page 9 (Tate Gallery/© David Hockney, 1967).
Llewellyn-Alexander Gallery: page 22 b.
Visual Arts Library: pages 6 (Tate Gallery/© 1993 Frank Stella/ARS, New York), 7 (Private Collection), 8 (Tate Gallery/*Whaam!*, 1963, © Roy Lichtenstein/DACS 1994).